THE CRITICISM
OF PHOTOGRAPHY AS ART

The Photographs of Jerry Uelsmann

John L. Ward

University of Florida Press
Gainesville

COPYRIGHT © 1970 BY THE STATE OF FLORIDA
DEPARTMENT OF GENERAL SERVICES

*Library of Congress
Catalog Card No. 71–630252
ISBN 0–8130–0303–2*

Fifth Impression 1975

PRINTED IN FLORIDA BY STORTER PRINTING COMPANY, INC.

Foreword

THREE YEARS AGO two graduate students in photography wrote papers for me in which they attempted to apply the techniques of art analysis and criticism (morphology, connoisseurship, etc.) to photographs. The results were disappointing. The students simply did not know how to make the techniques relevant to the analysis of photographs. My subsequent research into photographic literature made it evident that my students were not alone: I discovered only a handful of writers who had written important, sustained, analytical criticism of individual photographs in the entire history of the medium. And, although I found a vast body of literature which deals with photographic esthetics, most of it is made obsolete by current developments in both photography and esthetics. The present study is thus offered to the reader as a modest attempt to assess the value of the various partisan positions in photographic esthetics and criticism and to offer my own suggestions concerning what can be profitably written about meaning and value in photographs.

I wish to thank Jerry Uelsmann, whose photographs are the main subject of my analysis, for lending me photographs and books and giving me his ideas, encouragement, and much time. I am indebted to my colleague Jack Flam, with whom I originally undertook this study as a joint venture, for his helpful ideas. Dr. T. Walter Herbert, Professor of English at the University of Florida, and Peter C. Bunnell, Curator of Photography at the Museum of Modern Art, read the manuscript and suggested major changes which have improved it.

<div align="right">JOHN L. WARD</div>

Contents

Figures

Chapter 1

THE LITERATURE devoted to a critical discussion of photographs is meager and, for the most part, superficial and vague. Although photography only came into being in the last century, its practitioners have already produced a large body of excellent work which deserves far more intensive study and analysis in terms of its meaning and value than it has been accorded up to now. The failure of critics to discuss photographs in any depth has been deplored in strong terms by the very men who produced or encouraged such criticism as exists. Minor White, photographer and editor of America's most significant current photographic periodical, *Aperture*, wrote in 1953, "Photography is short on competent criticism today; and absolutely lacks great criticism."[1] Henry Holmes Smith, photographer, influential teacher at Indiana University, and writer of several of the most perceptive articles in *Aperture*, remarked in 1957 that, "compared with the abundant repetitious nonsense written about techniques and equipment and the accompanying induced hysteria over these subjects, intelligent critical literature on photographs is barely discernible. No other art of comparable importance in our time possesses a body of literature more imbalanced or generally humdrum."[2] And Bruce Downes, editor of *Popular Photography*, wrote in 1943 that "True criticism is the salt of aesthetics. In photography, however, there are not only no great critics, but even moderately competent critics are rare."[3] In 1962 he reminded readers of his charge and added, "Now in 1962 nothing has changed!"[4]

1. "Criticism," *Aperture* 2, no. 2 (1953): 27.
2. "Image, Obscurity and Interpretation," *Aperture* 5, no. 4 (1957): 136.
3. Quoted in "Critics Wanted," *Popular Photography* 50 (May, 1962): 50.
4. *Ibid.*

Why is it that so few critics have tried their hand at photographic criticism and why have their efforts been so generally mediocre? Perhaps in large part because photography presents special problems to the critic because it possesses certain qualities which cannot be reconciled with traditional esthetic systems. First, it is impersonal, it is made by machine, not by hand. At its most fundamental level, photography is a mechanical and chemical process to record light on a surface—most commonly, light which is reflected by people and things in the physical world. Early daguerreotypists were sometimes called "operators" or "conductors" because they were such passive agents in the process. At the turn of the century, numerous photographers tried to overcome this impersonality by techniques, such as bromoil and gum printing, which allowed them to leave their marks on the pictures. It is significant that this period produced some of the most successful sustained discussion of photographs in the history of photography. Critics seemed relieved to be able to deal with photographs in which they could see precisely what the photographer's role had been. Secondly, photography is indiscriminate. To be sure, the photographer selects what he wants to photograph and can alter the results in the development and printing up to a point. But one of the fathers of photography, William Henry Fox Talbot, pointed out that the camera "chronicles whatever it sees, and certainly would delineate a chimney-pot or a chimney-sweeper with the same impartiality as it would the Apollo Belvedere."[5] Despite the possibilities for subsequent alteration, the statement still holds true. This moral neutrality would seem to work against the artist's desire to intensify, to heighten, to select. And, although critics have professed to recognize the expression of ideas, feelings, and values in photographs, few have been able to explain precisely which formal qualities of a photograph conveyed them. A third difficulty for critics is that photography is easy. Although one can spend years perfecting photographic techniques, an untrained child can take exciting photographs (as did Jacques Henri Lartigue). So long as craft was considered an essential ingredient in art, critics had difficulty dealing with photographs.

Photography's credibility poses a fourth problem for critics. We accept a photograph as real not only because of its great potential to render meticulous detail but because we know (or sup-

5. *The Pencil of Nature*, 1844, reprinted in *Image* 8 (1959): 50.

pose) it to be a record of a particular place at a certain historical moment. This sense of the reality *behind* the photograph is so strong that frequently, and especially with people who are not used to viewing them as works of art, photographs become invisible windows with no intrinsic character. I do not mean, of course, that people are deceived into believing that they are looking at physical objects instead of a photograph of them. I mean that their attention is so entirely on the subject matter of the photograph that they have little sense of how that subject matter has been transformed in the picture. They have little awareness of how the objects have been altered by a new size, a relation to a frame or edge, a translation into tonal value on a flat surface. Few viewers notice the depth of focus, the amount of grain, the surface quality of the paper, the range of tonal scale, and the other basic properties of a photograph. Fewer still can explain the effect of these properties on the depicted objects. This inability to distinguish between the photograph and the subject matter was demonstrated by the art historian and critic Russel Sturgis, who wrote, "This is the essence of the photograph, that it preserves every record, with some drawbacks and shortcomings, of what is put before it. If that thing is artistic, the photograph, in an indirect and secondary way, becomes itself artistic, as the reflection of a man's face in a glass is the man himself; so far and no farther."[6] With such an attitude, criticism is impossible, except to the extent that we like the people or views which are presented to us. And even sensitive critics who are accustomed to dealing with photographs as objects with properties which are distinct from those of the subject matter are sometimes hard pressed to recognize which qualities come into being in the photograph that did not occur in the subject.

In addition to the formidable difficulties which photography presents to the critic, the refusal of many people, even now, to admit that it is a major art medium, capable of expressing profound insights and esthetic pleasure, has doubtless encouraged critics to turn their attention elsewhere. Many of the thousands of articles on photography which have appeared in the past 130 years were written with one of two audiences in mind: scientists or amateur hobbyists. The writing has been correspondingly technical or sim-

6. Kenyon Cox and Russel Sturgis, "The Lesson of the Photograph," *Scribner's Magazine* 23 (1898): 639.

plistic. Many of the remaining articles have appeared in publications edited by "pictorialists," photographers who consciously strove for artistic effect in their own work and demanded it in the photographs they criticized, but whose notions of art grew progressively more smug, narrow, and sterile as the mainstream of art left them behind. The regularity with which photographic magazines which seriously attempt to address problems of criticism go out of business or must struggle for survival indicates that there is still little audience for intellectually demanding photo-criticism.

It is neither possible nor especially desirable within the limits of this study to discuss the entire history of critical writing on photography. But a number of esthetic positions have been developed by photography critics, which, either because they have been widely held or because they are intrinsically significant, deserve our attention. Of these, the "purist" and "pictorialist" positions have always occupied the great preponderance of the literature—and usually in direct conflict with each other. The pictorialist position is described by P. L. Anderson in *Pictorial Photography, Its Principles and Practice* and the purist attitude by Edward Weston in articles in *Camera Craft* and the *Encyclopaedia Britannica*.[7] Pictorialism is based on the premise that a photograph can be judged by the same standards by which one judges other pictures (i.e., prints, drawings, and paintings); the purist position is based on the premise that photography has a certain intrinsic character and that the value of a photograph is directly dependent on fidelity to this character. To the pictorialist, photography is the means, art is the end; to the purist, photography is both means and end, and talk about art is highly suspect.

More specifically, however, most purists saw photography's ability to record objectively as its justification and viewed any techniques or methods which modified that objectivity as bad. Most pictorialists felt that a photograph could not be art unless the photographer somehow interfered with its objectivity. A few quotations may help to illustrate these points. First, Edward Weston, a photographer representing the purist view of photography: "*Fortunately* it is difficult to be dishonest, to become *too personal* with

7. See, for example, "What Is a Purist?" *Camera Craft* (January, 1939): 2–9; "Photographic Beauty," *Camera Craft* (June, 1939): 247–55; and "Techniques of Photographic Art," *Encyclopaedia Britannica*, vol. 17 (1957), pp. 801–2.

the very impersonal lens-eye. So the photographer is forced to approach nature in a spirit of inquiry, of communion, with desire to learn. Any expression is weakened in degree, by the injection of personality. . . .

"I do not wish to impose my personality upon nature (any of life's manifestations), but without prejudice or falsification to become *identified* with nature, to know things in their very essence, so that what I record is not an interpretation—*my* idea of what nature *should* be—but a *revelation*—a piercing of the smoke screen artificially cast over life by irrelevant, humanly limited exigencies, into an absolute, impersonal recognition."[8] Next, Helmut Gernsheim, a photographic historian and esthetician who embraces the purist tenets: "Following a superficial facet of a style of painting does not add to the value of a photograph but rather detracts from it. Flirtation with art only pays for a limited period. Respect for the photographic image will always remain the fundamental principle of good photography."[9] And finally, Charles H. Caffin describes the pictorialist view as it was represented by the Photo-Secessionists: "This group of 'advanced photographers' is striving to secure in their prints the same qualities that contribute to the beauty of a picture in any other medium, and ask that their work may be judged by the same standard. This claim involves two necessities: first, that the photographer must have as sound a knowledge of the principles of picture-making as the painters have; and, secondly, that it is within his power, as well as theirs, to put personal expression into the picture. It is not enough that he shall be an artist in feeling and knowledge, but that he shall be able so to control the stages of the photographic process that the print at last shall embody the evidence of his own character and purpose, as an oil-painting may do in the case of the painter."[10]

Since, in the eyes of the pictorialist, the aim of a photograph is art, many pictorialists believed that any means which were required to achieve that end were permissible. Thus, as early as 1861, C. Jabez Hughes observed that "a photographer, like an artist, is at liberty to employ what means he thinks necessary to

8. *The Daybooks of Edward Weston*, ed. Nancy Newhall, 2 vols. (New York, 1966), 2: 241.

9. *Creative Photography: Aesthetic Trends 1839–1960* (Boston, 1962), p. 207.

10. *Photography as a Fine Art: The Achievements and Possibilities of Photographic Art in America* (New York, 1901), p. vii.

carry out his ideas. If a picture cannot be produced by one negative, let him have two or ten; but let it be clearly understood, that these are only means to the end, and that the picture when finished must stand or fall entirely by the effects produced, and not by the means employed."[11]

In theory, then, pictorialist photographers' view of art as their objective allowed for a radical exploration of means restricted only by their ability to utilize them effectively. And, indeed, a few rare photographers, such as Francis Brugiere, did actually reconcile an experimental approach with essentially artistic concerns. But it has only been in recent years, as exemplified by the work of Jerry Uelsmann and Ray Metzker, that such a combination of interests has received widespread enthusiasm and acceptance. For the most part, the pictorialists' relationship to art has been sterile. Paradoxically, and to a far greater extent than in the case of the purists, most pictorialists were unable to comprehend or accept the revolution which overturned all of the arts in this century. Their theories of what photographs should look like were based to a surprising extent on two sources: nineteenth-century pictorialists looked to the writings of John Burnet, such as A Treatise on Painting and Composition and Light and Shade and twentieth-century pictorialists depended on the insights of Henry R. Poore in his books such as Pictorial Composition and the Critical Judgment of Pictures. Henry P. Robinson frankly admitted his debt to Burnet, and P. L. Anderson credits Poore as the source of many of his ideas. All four writers proceed on the assumption that rules of formal organization, although they must be responsive to the kind of subject matter being presented, remain constant during all periods of history. They do not admit that style should vary according to the particular world view which is being represented; they believe that their rules, derived from pictures which for the most part were painted between 1500-1850, are valid for all pictures. The three most fundamental rules are these: there must always be a dramatic center of interest and a subordination of the other parts; balance cannot be symmetrical and static, but must set up a spatial flow; and there must be a sense of breadth to the forms. Thus—and this is a point which has been too often overlooked— the esthetic basis of pictorialism was flawed not because it applied

11. "Art-Photography: Its Scope and Characteristics," *The Photographic News* 5 (January 4, 1861): 4.

painting standards to photography, but because it set up principles which were only relevant to a specific *Weltanschauung* as fixed standards of value: they were not necessarily appropriate to either the painting or the photography of the last hundred years. But one must emphatically insist that, however narrow the pictorialist position tended to be and however drab and characterless most of the pictorial photographs were, such photographers as Edward Steichen, Robert Demachy, Frank Eugene, Gertrude Käsebier, and J. Craig Annan produced work which refutes smug attempts to write it off as worthless.

And, despite the limitations of the pictorialist teachings, pictorialist critics have written some of the best critical discussions of photographs. Pictorialist criticism reached its high point in the first decade of this century in the sensitive, though somewhat general, discussions of writers such as Charles H. Caffin and Sadakichi Hartmann. They discussed the works of important photographers analytically and in terms of the general character expressed by the photographs.

But pictorialists have also written most of the worst photographic criticism. This has usually taken the form of subjecting the photographs of hapless amateurs to rigid laws of pictorialism and has appeared regularly in such photographic magazines as *The Photographer, Photo-Era, American Photographer, Camera Craft,* and *Popular Photography.*

Purism, on the other hand, has produced little critical literature. Beaumont Newhall's *History of Photography* and Helmut Gernsheim's *Creative Photography* contain critical judgments by men in the purist camp, but there is scant visual analysis to back them up. Perhaps, indeed, purism can only function as a negative critical principle; that is, one can reject as unphotographic those photographs which use darkroom "tricks" to modify the original image, but there are no standards to rate those which are left. And even the separation of pictures which are genuinely photographic from those which are unphotographic or "painterly" is not as clear-cut as it seems to be. László Moholy-Nagy called Stieglitz painterly,[12] Helmut Gernsheim claimed that Moholy-Nagy confused the ends

12. He wrote of a Stieglitz photograph, "Der Sieg des Impressionismus oder die missverstandene Fotografie. Der Fotograf ist Maler geworden, anstatt seiner Apparat *fotografish* zu benutzen." In *Malerei Fotografie Film* (Munich, 1927), p. 47.

of photography and painting,[13] Clement Greenberg claimed that Weston's photographs were a confusion of photography and painting,[14] and even the arch-pictorialists Robinson and Anderson protested against certain photographs as being unphotographic.[15] As a creative esthetic, purism had a fruitful history. It encouraged photographers to explore the world in exciting, new ways and taught them not to be concerned that their work failed to look like what critics expected art to look like. But as a basis for criticizing all photographs it is as one-sided as pictorialism. It must be noted, however, that, although the hostility which exists between these two groups has existed considerably longer than the names purist and pictorialist, the principles which they have advocated are not mutually exclusive: many pictorialists have acknowledged the importance of utilizing photography's special qualities wherever they could be useful, and many purists acknowledged the value of comparing photographs with other art work.

Another attitude allied to the purist approach in its de-emphasis of photography's ties with art and its concern with the properties of the medium (which they viewed very differently from Weston) was developed by Moholy-Nagy and the other workers at the Bauhaus. They employed photographs largely as a means of educating and expanding vision rather than for any pictorial significance.[16] Because they saw photographs more as means (tools) than as

13. In commenting on Moholy's statement quoted in note 12, Gernsheim wrote, "If 'abstract art' is substituted for 'Impression,' this verdict applies to most of Moholy-Nagy's own photographs far more than Stieglitz's. The American photographer at least pursued the proper aims of photography, whereas the Hungarian painter was concerned with image-making for his own aesthetic ends" (*Creative Photography*, p. 168).

14. In a review of a Weston show he wrote, "Weston's failure is a failure to select; which is moved in turn by a lack of interest in subject matter and an excessive concentration on the medium. In the last analysis this is a confusion of photography with painting . . ." ("The Camera's Glass Eye," *The Nation* 162 [March 9, 1946]: 295).

15. Robinson wrote that "if studies in light and shade only are required, let them be done in pigment or charcoal, with a mop, if necessary, but photography is pre-eminently the art of definition, and where an art departs from its *function* it is lost" (*Pictorial Effect in Photography* [London, 1869], p. 145). Anderson observed that "an evident mixture of mediums is a hybrid and an abomination, and the effort of some workers to produce photographs resembling in texture or quality the effects of pencil or charcoal drawing, etching or lithography, are foredoomed to failure" (*The Fine Art of Photography* [Philadelphia, 1919], p. 31).

16. See László Moholy-Nagy, *The New Vision* (New York, 1938).

ends (art), this view produced little actual written criticism of photographs as individual things. It did, however, greatly expand accepted notions of both the subjects and use of media which were proper to photography.

A third means of evaluating photographs we may call "intentionalist criticism." Unlike purism and pictorialism, this approach is not a creative esthetic; that is, it does not recommend any values to the photographer. It is exclusively a critical view, and it is employed by both purists and pictorialists. It is espoused in an unqualified form by A. Kraszna-Krausz, editor of *The Focal Encyclopedia of Photography*: "The purpose of the photographer in making a particular picture must receive first consideration; whether his work appears to fulfil that purpose or fall short of it is, in fact, the only point that really matters. If the man behind the camera happens to be solely concerned with some rare or subtle expression in his subject's face then he should be criticized only on account of anything that may distract from that expression, no matter whether the distracting element by itself represents good or bad photography."[17] Other intentionalists have recognized the inherent difficulties of this position, but their efforts to avoid them have only complicated the situation. For example, Minor White, who has stressed the importance of understanding the artist's purpose, has noted, first, that the mere fulfillment of the purpose may not guarantee a satisfactory photograph if the purpose is reprehensible; second, that the artist may not be available to explain what his purpose was; and, third, that it is possible that the photograph may have value for reasons which have nothing to do with the photographer's intentions, since "photographers frequently 'photograph better than they know.' "[18]

Despite the fact that a number of systematic approaches to photographic criticism based on intentionalism have been outlined in photographic literature, the effects of this approach are rarely apparent in published photo-criticism. Indeed, the literal application of Kraszna-Krausz' position makes criticism futile, since any failure in a photograph may actually be a success if the photographer intended to produce it, no matter how trite or unimaginative the intention was. And White's qualifications so circumscribe and complicate

17. *The Focal Encyclopedia of Photography* (New York, 1960), p. 281.
18. *Aperture* 2, no. 2 (1953): 29–30.

the approach that one wonders why he insists on retaining it at all.[19] A perhaps equally important reason for the paucity of intentionalist criticism as such is the tendency of many intentionalists to downgrade the importance of the photograph and to emphasize the creative vision of the photographer. For these writers, the photographer's intention, his vision, his view of reality, and his values are of prime importance; his photographs are only an imperfect means to reveal these things. Thus Stephen G. Perrin remarks that, unhampered by the necessity of learning to render illusion and master technique, "the photographer is free to concentrate on the externalizing of his inner vision. . . . If photography has anything at all to do with reality, it represents a sort of colloidal suspension of the individual realities of all its practitioners; that is to say it has nothing whatsoever to do with reality in any rigidly defined sense. It is possible through photography to enter another man's world."[20] Further, in the photographs which he discusses, in a rare example of explicit intentionalist analysis, Perrin claims that the real meaning is extrinsic to the subject matter: "Something is definitely going on here that has nothing to do with the objects that are depicted. Something is seemingly overlaid upon these objects by the photographer. Essentially, it is a projection of tension that has nothing whatsoever to do with the objects themselves. That tension is the true subject of this series of images."[21] If this is so, it follows that the meaning of a photographer's pictures can be explained more directly by describing the photographer's intentions, his "vision," and his personality than by an analysis of his photographs. For example, Lincoln Kirstein's introductions to books of photographs by Walker Evans and Henri Cartier-Bresson, totalling seventeen pages of text, do not mention a single photograph as an entity.[22]

I do not wish to suggest that no meaningful criticism is possible unless it treats photographs as single, discrete objects. Actually, it happens that much of the most perceptive and sensitive critical

19. Especially damaging to the intentionalist position is White's observation that "with only slight exaggeration one can say that photographers know less than anyone else about what their pictures communicate or evoke, convey or suggest" ("On the Neglect of Visual Literacy," *Aperture* 5, no. 4 [1957]: 135).

20. "Editorial," *The Boston Review of Photography* 3 (November, 1967): 9.

21. *Ibid.*, pp. 9–10.

22. Walker Evans, *American Photographs* (New York, 1938); Henri Cartier-Bresson, *Photographs by Cartier-Bresson* (New York, 1963).

writing on photography yet published has discussed the character, style, and value of a photographer's work in general, with only rare examples cited. Judith Mara Gutman's book *Lewis W. Hine and the American Social Conscience* is an instance of the keen insights that such an approach can provide when used by a perceptive critic. But the emphasis of the present study is on the problem of criticizing individual photographs, and my review of photographic esthetics and criticism is weighted accordingly.

It should also be noted that the tendency of critics to emphasize intentions and to avoid analysis of photographs except in generalities is not entirely the outgrowth of their esthetic positions. Introductions to books or portfolios of a photographer's work and reviews of photographic exhibitions—which, together with criticism of amateur photographs, constitutes the vast bulk of photo-criticism—are obliged to provide a general estimate of the photographer's stature as a picture-maker and rarely have sufficient space to dwell on specific pictures.

A fourth approach related to photographic criticism has been almost entirely confined to the pages of Minor White's magazine *Aperture*. This method, which White calls "reading," is a process of photographic analysis accompanied by the suspension of critical evaluation, and it represents one of the few significant attempts within recent years to provide a method of understanding single photographs. Unlike nearly all other critical approaches, it assumes that certain photographs are complex structures of meaning, loaded with overtones and implications which can only be gotten at by determined contemplation. Photographs of this variety White calls "Equivalents," borrowing Stieglitz' term. According to White, "Any photograph is an Equivalent, regardless of whether a pictorialist, scientist or reporter made it, that somehow transcends its original and customary purposes, i.e., transcends instinctive subject, emotional manner, and intellectual information, and furthermore transcends these parts in unison."[23] Because of this transcendence of its original purpose, the intentionalist approach is of little use in understanding the Equivalent, and the viewer is forced to come to terms with only that information directly given by the photograph itself. In using this method, White and Henry Holmes Smith have been influenced by the observations on the criticism of poetry in I. A.

23. Minor White and Walter Chappell, "Some Methods for Experiencing Photographs," *Aperture* 5, no. 4 (1957): 161.

Richards' *Practical Criticism*. Smith points out that Richards' enumeration of certain difficulties which typically obscure or alter the meaning of a poem is especially valuable for reading photographs.[24] It should be noted that reading is not criticism, since value judgments are avoided. Its object is simply to point out a photograph's meanings, implications, and overtones. Smith has written to me that "'reading of photographs' at IU [Indiana University] was taken up in the attempt to require the student to pay attention to the photograph as something separate from what he associated with it, what others projected on it, and even what the photographer intended." Examples of published readings have appeared in only half a dozen issues of *Aperture*, and in recent years they have not been found even there. Perhaps White and the others involved in this effort to shed light on photographs finally became discouraged by the difficulties of preventing readings from becoming purely subjective and arbitrary. White noted in 1957, after studying the results of an experiment in reading photographs, that "it was also becoming painfully obvious that, with all due respect to the 'readers' and in full appreciation of their generous efforts, that 'reading photographs' is an uncertain field. Perhaps only the most rudimentary knowledge exists in it."[25] Yet it is probable that part of White's difficulties grow out of a fundamental fallacy in the concept of reading itself, namely, in White's words, that "once evaluation is either suspended or removed by an early decision to do so, one can concentrate on the significance of the picture."[26] It must seriously be questioned whether decisions concerning significance are in fact separable from decisions concerning value. In my judgment, every insight into a photograph's significance simultaneously alters the viewer's evaluation of it, and, conversely, every intuition of value in a photograph is based on a real or imagined insight into its meaning. Henry Holmes Smith observed this connection of value and meaning in an experiment with student readings of photographs and concluded that "only photographs deeply felt to be 'worthwhile' by the person looking at them should be used in any future study."[27]

24. *Ibid.*, p. 138.
25. "While the Readings Were Being Edited," *Aperture* 5, no. 3 (1957: 128.
26. "What Is Meant by 'Reading' Photographs," *Aperture* 5, no. 2 (1957): 49.
27. "Image, Obscurity and Interpretation," *Aperture* 5, no. 4 (1957): 140.

A final approach to photographic analysis exists in a single example: this is William E. Parker's article "Uelsmann's Unitary Reality" which appeared in 1967 in *Aperture*.[28] It is based on a search for archetypal symbols in Uelsmann's work and implies that the value of his pictures is caused by the manipulation of these symbols to awaken ideas which lie at the roots of all human experience. It is the recognition of the picture's supercharged reality to which the viewer responds. Despite Parker's recondite and torturous prose and a certain dogmatism, the article is a milestone in the upgrading of photo-criticism. It moves with ease from a discussion of visual detail in individual photographs to their broader overtones and more elusive meanings, and, as it elucidates them, it simultaneously accounts for their power and sureness. It remains to be seen whether an archetypal approach would be as successful in dealing with photographs which were based on different premises, and even in dealing with Uelsmann's work certain values were emphasized at the expense of others. But in the empty desert of photographic criticism, Parker's article is a welcomed oasis to lost, thirsty travelers.

The net which I have used to catch the various species of photographic criticism is woven large; doubtless some smaller varieties have slipped through. But, like a conscientious fisherman, I have tried to repair all of the larger holes, so that none of the more important critical approaches could elude me. What I have dredged up may seem a rather random catch. But it should be noted that all five approaches—pictorialism, purism, intentionalism, reading, and archetypal analysis—have close and numerous parallels with clearly defined critical approaches toward other media.

Pictorialism has its parallel in the ancient doctrine, revived in the Renaissance, *ut pictura poesis* (as in painting, so in poetry), which maintained that "Painting and Poesy are two Sisters, which are so like in all things, that they mutually lend to each other both their Name and Office. One is call'd a dumb Poesy, and the other a speaking Picture."[29] Consequently, rules developed for one medium could be applied, *mutatis mutandis*, equally well to the other.

Purism had its beginnings in Gotthold Lessing's skillfully argued book *Laocoon* (1766). Lessing protested that the prevailing prac-

28. 13, no. 3.

29. Charles Alphonse du Fresnoy, *The Art of Painting*, 1716, excerpted in Elizabeth G. Holt, *A Documentary History of Art*, 3 vols. (New York, 1957), 2: 164.

tice of forcing painting and poetry to do each other's tasks was a misunderstanding of what the ancients meant by *ut pictura poesis*: "They confined the saying of Simonides to the effect produced by the two arts, not failing to lay stress upon the fact that, notwithstanding the perfect similarity of their effects, the arts themselves differ both in the objects and in the methods of their imitation."[30] The result of this literal interpretation of parallels between the arts, wrote Lessing, was that "In poetry, a fondness for description, and in painting, a fancy for allegory, has arisen from the desire to make the one a speaking picture without really knowing what it can and ought to paint, and the other a dumb poem, without having considered in how far painting can express universal ideas without abandoning its proper sphere and degenerating into an arbitrary method of writing."[31] But although Lessing's approach freed artists to work unhampered by rules formulated for another medium, his delimitation of the proper spheres of sculpture and poetry based on what he conceived to be their fundamental properties was nearly as confining from a different direction.

The background of the intentionalist position is reviewed and its implications are brilliantly refuted in W. K. Wimsatt, Jr., and Monroe C. Beardsley's well-known essay, "The Intentional Fallacy." They point to Goethe's three questions for "constructive criticism" as an early example of intentionalism: "What did the author set out to do? Was his plan reasonable and sensible, and how far did he succeed in carrying it out?"[32] In place of Minor White's observation that we cannot *always* know what the photographer intended, they assert that, since the poet's (for our purposes, the photographer's) intention (what he *meant* to say) is constantly being modified until the poem is finished (or the picture taken), the only conclusive evidence of his intention is the work itself. And further that, since all parts of a poem (or photograph) simply exist as parts, it is not possible to determine which the artist intended and which are accidental: "A poem can *be* only through its *meaning*—since its medium is words—yet it *is*, simply *is*, in the sense that we have no excuse for inquiring what part is intended or meant. Poetry is a feat of style by which a complex of meaning is handled all at once. Poetry succeeds because all or most of what is said or implied is relevant;

30. Trans. Ellen Frothingham (New York, 1965), p. ix.
31. *Ibid.*, p. x.
32. *The Verbal Icon* (New York, 1964), p. 6.

what is irrelevant has been excluded, like lumps from pudding and 'bugs' from machinery."[33] Wimsatt and Beardsley emphasize that their remarks are intended strictly for poetry. Yet, despite appearances, they hold true of photography as well. Take, for example, White and Chappell's first step in their method for experiencing documentary photographs: "Note whether background is intended to relate to subject or is unintentionally superfluous. If the latter, please disregard; if the former, anticipate relating."[34] How, one may ask, is it possible to tell whether the background is intended *except* by deciding whether it strengthens or weakens the subject? (How, indeed can one tell what the subject *is* except by deciding what is strong or weak in a photograph?) It appears that the only way in which we can determine a photographer's intention is by assuming that the forms which work (to convey a forceful meaning) are intentional and those which are incoherent or distracting are accidental. All we can really do is point out which parts work and which do not.[35]

Reading is an application to photography of the literary practice of explication—a long-standing method which was greatly elaborated at the beginning of this century through the emphasis which certain critics, such as I. A. Richards, William Empson, T. S. Eliot, and the group known as the New Critics, placed on a thorough analysis of the manner in which a piece of literature "works," how its subject, development, rhyme, rhythm, etc. interrelate. This elaboration of the use of methodical analysis, ironically, seems actually to have stimulated extravagant and irrelevant interpretations of art works at the hands of insensitive critics. But when explication has been employed with intelligence it has been singularly successful in dealing with the special nature of each art work. As with reading, however, there has been a hesitancy on the part of some explicators to regard value judgment as part of their job.[36]

Archetypal criticism is a relatively recent development, but it has already been applied to art in many media. It derives from Jung's hypothesis, set forth in his article "On the Relation of Analytical Psy-

33. *Ibid.*, p. 4.
34. "Experiencing Photographs," p. 163.
35. On the other hand, Goldwater justly protests against critics who interpret every stylistic property as a deliberate and meaningful product of an artist's intention. Robert Goldwater, "Problems of Criticism I: Varieties of Critical Experience," *Art Forum* 6 (September, 1967): 40–41.
36. See Wimsatt's remarks in *The Verbal Icon*, pp. 245–51.

chology to Poetic Art," that certain kinds of art present archetypal images to which we respond because they stir a "collective unconscious," a "psychic residua of numberless experiences of the same type" which have happened to mankind for so long that they have somehow been inherited in the structure of the brain.[37] Maud Bodkin's *Archetypal Patterns in Poetry* and Erich Neumann's *The Archetypal World of Henry Moore* are examples of its applications. When handled with sensitivity, it is capable of striking insights into the character of an art work, but the approach may encourage lesser critics to criticize works which fail to follow the archetypal patterns or interpret things as archetypes which do not function that way in a given work. In short, there is the danger that, instead of waiting to experience the unique character of each art work, the archetypal critic may assume that its value *must* come through its archetypal appeal to the collective unconscious and may criticize it from this narrow perspective.

A study of the evidence thus makes it clear that few of the issues raised by photographic criticism are new—that virtually all attitudes toward the criticism of photography, knowingly or unintentionally, reiterate positions, frequently centuries old, which were originally formulated for other media.

37. *The Spirit in Man, Art, and Literature,* vol. 15 of *The Collected Works of C. G. Jung* (Princeton, N.J., 1966), p. 81.

Chapter 2

BEFORE I EXPLAIN my approach to photographic criticism, let us recall the standards formulated by previous critics to see where their weaknesses lie. The pictorialist believes that principles which were useful in describing the art of one medium and one historical period can be employed with little modification as fixed rules which are appropriate to any photograph intended as a picture. This approach is not meaningful because it is not reasonable or necessary; other historical periods and other media offer different possibilities which are equally effective as pictorial devices and equally able to produce meaningful art. But the failure of the pictorialists lay not in claiming that photographs, paintings, and prints should be judged by the same standard; it was in their inability to formulate a standard broad enough to be relevant in all cases.

The purist believes that a photograph should be true to the nature of the medium. Now, it is clear that every medium has certain properties which can be developed more readily than others, or that separate it from other media. But these properties have value only in terms of some purpose or use, whether it be scientific, commercial, or artistic. Most uses of photography, such as social documentation, aerial reconnaissance, and micro-photography, are for the purpose of recording a specific kind of information about things in the phenomenal world, and the value of the photographic properties (grain, sharpness, contrast, etc.) can be measured by how much of the desired information they yield. But photographs can also be made to be enjoyed and valued as self-contained images, that is, as pictures. And if a photograph is to be judged as a picture, then the only legitimate standard must be based on its significance *as a picture*. The formal properties can be evaluated only in terms of their effectiveness in the final image. It may still be argued that a sharply

focused, unmanipulated photograph with a full tonal range, composed by intuition rather than by rule, stands the best chance of being a significant picture, but this judgment will have to be proved in each case.

The intentionalist believes that standards must be set by the photographer. That is reasonable if we view photographs as experiments done for the photographer's own benefit. But it should be clear that a photograph can be important as a picture for reasons that the photographer did not consciously intend and may not even have been aware of, and, conversely, it should be clear that a photograph may be a poor picture—dull, confused, or trite—even though it satisfies the maker.

As for the other two approaches to photography mentioned in the first chapter, neither one attempts to offer value standards which could be applied to different kinds of photographs.

Although only a relatively small percentage of photographs are made for their value as pictures, rather than for the value of the information they record, nearly all written criticism concerns the *pictorial* value of photographs. That is because, if we are interested solely in information, we have only to determine how successfully that information has been conveyed in a given photograph. We can also predict fairly accurately what kind of camera, film, aperture, speed, etc. will produce the best results. Little controversy concerning value is consequently likely to arise. But judging the value of a photograph as a picture is a far trickier business and all too often critics have been sidetracked into irrelevant issues. Why is it important that a photographic picture follow standards which even the best painting has not adhered to for over a century? Why is it necessary for a photograph to look like what we expect a photograph to look like to be a successful picture? And why, if the photograph is visibly successful as a picture, is it necessary to find out what the photographer intended in making it?

It remains to be seen, then, whether there is a way of judging the value of photographs as pictures by some fixed standard of quality without setting up rules for what a photograph should look like. I believe that there is such a way; it involves treating photographs as works of art. Such an approach has been attempted many times, yet nearly always it has been based upon an inadequate definition of art, one which limited pictorial possibilities.

It may fairly be asked what we stand to gain by treating photo-

graphs as art works. The answer is that by so doing we acknowledge that when we look at a photograph as a thing in itself, rather than for any useful information it contains, the value which we perceive, if any, is essentially the same kind of value present in other works of art. To be sure, a photograph works differently from art in other media—and photographs differ from one another—but their value is the same kind of value, esthetic. If this is so—and we will return to the point later—than photography stands to profit enormously from the esthetic and critical writings of other media. We have already seen that all of the major positions of photographic criticism reflect ideas (or independently have arrived at ideas) previously applied to other media. Consequently, study of this literature by photographic critics would permit them to move beyond the elementary stages of critical analysis at which they typically operate.

Nor do we need to formulate any rules about what photographs should look like in order to consider them as art. Pictorialist claims to the contrary, artistic value is uniquely unpredictable. It is like a stranger whom we are supposed to meet at the airport: we do not know what it is going to look like until we encounter it. Clement Greenberg characterized the critical experience thus:

> . . . A precious freedom lies in the very involuntariness of esthetic judging: the freedom to be surprised, taken aback, have your expectations confounded, the freedom to be inconsistent and to like anything in art as long as it is good—the freedom, in short, to let art stay open.
>
>
>
> Despite certain qualms . . . you relish the fact that in art things happen of their own accord and not yours, that you have to like things you don't want to like, and dislike things you do want to like.
>
>
>
> You cannot legitimately want or hope for anything from art except quality. And you cannot lay down conditions for quality. However and wherever it turns up, you have to accept it. You have your prejudices, your leanings and inclinations, but you are under the obligation to recognize them as that and keep them from interfering.[1]

1. "Problems of Criticism II: Complaints of an Art Critic," *Art Forum* 6 (October, 1967): 38.

I most enthusiastically agree with these ideas. Precisely what artistic quality is and how we recognize it will be discussed presently.

But the usefulness of treating photographs as art will largely depend upon the care with which we define art. Our definition must touch the central qualities of all art. We must be careful not to include anything that is unessential, so that we may be sure we do not rule out any art works from consideration. Our definition must be large enough so that any art from the past or the future will be covered by it, but it must be precise enough so that we are able to prevent extraneous considerations from affecting our judgment of it.

What, then, is common to all art? Detractors of photography believed that a work of art must be made by hand, but such a criterion would today rule out much painting and sculpture as well as photography. Machine-made works of art, whether photographs, paintings, sculpture, or computer music, despite the new properties given to them by their mechanical creation, present themselves to the audience in essentially the same way as other art. We can still recognize the work of one artist (or programmer) from that of another and we can recognize some work as meaningful and interesting and other work as dull.

Definitions of art have sometimes included the idea that art must express the emotions and values of the artist. Undoubtedly such expression does occur in most and perhaps all art. But, as I argued in the first chapter, in refuting the intentionalist position, we cannot really be sure what the artist feels or believes, and it does not matter anyway; the only emotions and beliefs which count are those which are presented in the work of art, either explicitly or indirectly.

We may then ask whether an artist is a necessary requirement to the existence of a work of art. Would a profile of a face silhouetted by natural forces in the rocks of a gorge and given a name by the natives of the region be a work of art? Would a still frame from film shot by an aerial reconnaissance plane with an automatically operated camera be a work of art? I would suggest that the answer could be yes. It is obvious that the role of chance is so great in these examples that the possibility of any great esthetic significance is slight. But it is important to pursue our inquiry concerning the limits of art as far as we can go so that nothing extraneous gets into our definition and nothing of value is left out. It may be difficult for some readers to believe that a thing which is not made

with some explicit value and meaning, but which only happens by accident, can have any meaning in it. But this is precisely what typically occurs in "straight" photography. The photographer who deliberately takes his picture chooses one configuration from an environment in a constant state of flux because he sees meaning in it. He does not have to *put* the meaning in the picture but only to recognize it and fix it on film. If the photographer were to shoot his pictures completely at random and only select the ones he wanted to use afterwards, his chances of producing significant pictures would be greatly lessened, but his pictures would not necessarily be different in kind from those which he planned in every detail. The artistic act of selection would only have occurred at a later point in the process. An objection may also be raised that a thing cannot be called a *work* of art if there is no work involved —if, for example, the thing is found. True enough, and perhaps we should use the term "esthetic object." But I think that making such a strong distinction between made and found objects obscures the fact that the value of both as art resides not in how they came to be but in what they are when complete. So I will continue to use the term "work of art" for all art objects because it is convenient, if inaccurate, and because the pictures I will consider in this study are, in fact, made by men.

If a work of art does not have to be man-made, can anything be a work of art? A tree, for example, or a woman? We seem to reach a point where things become so entangled in nature that it is simply too difficult and unrewarding to think of them as art. I would suggest, however, that the things in nature which look most like art, so that the boundary becomes extremely difficult to draw, are those things in which nature seems the most purposive: in snowflakes, in crystals, in pods—in things, that is, which have a complete, highly structured form. What sets these things apart from the rest of nature is that nature, as we experience it in our daily lives, seems continuous, seamless, interacting, and random. Intellectually, we know this is not entirely true; everything in nature is governed by laws. But we *experience* nature as random and accidental. Thus, the perfect symmetry of a snowflake is always a surprise because it manifests in an immediate, sensory way an order which we apprehend in nature only faintly. In this sense it is possible to say that a snowflake, a crystal, or a pod is more *real* than other natural phenomena because it presents in intensified form a kind of mean-

ing which, to an extent, underlies all nature. I do not believe that it is useful to call snowflakes works of art. Unlike a face carved in a mountain by the action of nature which, although made by nature, has a meaning which is quite separate from nature, a snowflake is always part of nature. But by recognizing its resemblance to art, we may come to a clearer understanding of what art is.

Other, less structured things in nature also arouse our esthetic responses: spectacular mountains, gnarled trees, the desert in a shower. The deciding element always seems to be that the object or scene has been able to separate itself from the background level of normal experience so as to be capable of expressing and metamorphosing states of feeling and kinds of reality.

After these tentative explorations, we are ready for some more positive attempts to delimit art. A very useful insight is provided by Susanne K. Langer's excellent book *Feeling and Form: A Theory of Art*. Langer proceeds on the assumption that the essential qualities which works of art have in common do not depend on the manner of their creation, but on their appearance. She observes that the most immediate impression created by every real work of art "is one of 'otherness' from reality—the impression of an illusion enfolding the thing, action, statement, or flow of sound that constitutes the work."[2] The strangeness or otherness which characterizes the work of art occurs because "the form is immediately given to perception, and yet it reaches beyond itself; it is semblance, but seems to be charged with reality."[3] These remarks seem to me to touch what is the fundamental property of art: it is detached from the rest of the world in that all of its parts are charged with a heightened meaning—none of its relationships seem accidental, all of its properties seem important to its meaning. But it is also related to everything else in the world—it is, in fact, a kind of crystallization of the essence of the phenomenal world in a form which can be immediately perceived.

But defining art as those things which evoke this sense of charged reality is problematic. Even the greatest work of art does not always produce this sense of otherness or super-reality. Even if we are perceptive enough to see how the work functions, we do not always experience this sense of illusion. If we live with a painting on permanent display, we perceive it most of the time as furni-

2. (New York, 1953), p. 45.
3. *Ibid.*, p. 52.

ture. Only when all of our attention is focussed on it does it usually come alive, does its sense of charged reality function fully. Conversely, almost anything can acquire a sense of heightened reality and presence if it is detached, physically or by contemplation, from its environment. This is the principle of found objects. Of course, some things do this better than others. Thus, although it seems to me that what counts about art is its ability to produce a sense of heightened reality, this sense is not a quality which is built into the work of art, but which is produced by the interaction between the work and a viewer who is looking at the work as art. Art cannot function without a responsive viewer.

Perhaps we must simply say that a work of art is anything which is separable from nature and which is contemplated for that portion of its meaning which may be intuitively experienced apart from its practical value. Given a responsive viewer, such contemplation of the art work should produce a sense of heightened reality and presence. This definition properly sets no limits on how the art work came to be or what it looks like; it does insist that the end of art is understanding produced through direct intuition. No meaning matters in art unless it is directly or indirectly made known by a piece's experienceable properties; the relevance of any interpretation can be estimated by the degree to which the experienceable properties confirm it, but such confirmation can only be verified intuitively.

Regrettably, perhaps, such a broad definition of a work of art does violence to the concept of "a work," and even the relationship between art and artifice is disposed of. But only such an inclusive definition is capable of including past, present, and future developments in art. As soon as we recognize that the autographic touch of the artist need not be present in the work of art (as we always have in architecture), the inclusion of found objects is a logical step. And the found object completely obliterates the line between maker and viewer. Here, the artist is simply the first viewer to recognize the value of the thing as art and to so declare it.

I have deliberately defined art in terms of what it is and does instead of how it came to be. I do not mean by this to slight the creative role of the artist who brings most art—and certainly nearly all great art—into being. But I have omitted consideration of the creator in my definition because I believe that it is unnecessary and confusing. If we recognize something as art, then we can deal

with it as art, whether or not we know how it came into being. And we alleviate photographers who do not wish to be called artists of that embarrassment. Photographers may feel completely satisfied in documenting slum conditions, studying the motions of tennis players, or experimenting with the interaction of light-sensitive materials, or they may make their pictures for the expressed purpose of being exhibited in galleries. Their intentions make not the slightest difference to the value of their photographs, as art. Especially in photography, the person who thinks of himself as an artist has frequently achieved artistically poorer results than the photographer who cringes at the word.

By opening the doors of art to all comers, we avoid the categorical repudiations which Helmut Gernsheim makes in his book *Creative Photography*—repudiations which only confirm the validity of many photographers' fear of art. He remarks that "in considering the artistic aspects of photography we are not concerned with photographs intended to serve scientific or technical purposes," and that "we can also ignore the billions of snapshots taken every year by the estimated hundred million camera users all over the world for no other purpose than to serve as mementos of family events and holidays."[4] It is perhaps because Gernsheim has pursued such a policy that he almost overlooks the stunning pictures of Jacques Henri Lartigue. Likewise, John Szarkowski's book *The Photographer's Eye* introduces us to photographs of great artistic worth, many of which are endangered by Gernsheim's rules for art. Art would be poorer without them.

By insisting that the value of photography as art exists independent of its value as anything else (e.g., a document) and that this value can be judged only by a direct confrontation with the picture itself, we clarify the value of kinds of pictures which frequently have been slighted, such as various combinations of photography with painting and drawing as well as purely photographic collage. Under these rules, *a priori* standards, such as those set up by proponents of "pure" photography, have no importance. We are obliged to face the picture without any other requirements than that it work, that it be forceful and meaningful. If the picture seems to depend on photographic qualities for any of its artistic value, then it is within the purview of the photographic critic, and one would expect that he would have some insights to bring to it,

4. (Boston, 1962), pp. 12–13.

no matter whether the picture takes the form of photographs combined with painting or painting which is done from photographs.

Now that the purpose of art has been defined as insight through the direct revelation of an intensified reality, it is possible to measure the value of any work of art by a single standard—how well this purpose is accomplished. But of what use is such a general and personal criterion as intensified reality as a value standard? I have already admitted that the intensity of the art work's reality appears differently to the same person at different times; it should also be clear that different people experience it differently. Is our standard of any use in this world of constantly changing perceptions? It is certainly no guarantee of infallible judgment; it seems entirely likely that, even if everyone were to agree to this standard, people's evaluations of works of art would scarcely be changed at all. But such a standard will at least help us to recognize whether we are actually talking about the same thing. When we value art in terms of its whole experienceable meaning, everything else falls into its proper place as a means to this end or a consequence of it. Use of the medium, rules of composition, and treatment of subject matter can all be judged by how effectively they produce convincing meaning.

And other standards which have been used to judge art find their proper relationship to the standard of meaningfulness. Pleasure, often believed to be the proper end of art, arises from two causes. First, we may experience pleasure because of our partiality to the subject matter or the sensuous quality of the materials, or because we admire the artist's technical facility. But, because such partiality prejudices us toward (or against) a work, it may constitute an interference with art's ability to evoke a unique heightened reality. The second source of pleasure in art arises out of our recognition of a work's insight and is of value not for itself but as a sign that we understood the work. Beauty, another standard of excellence for art, can serve as a universal standard only if we can distinguish it from the beauty of the subject matter and the material substance of the art work. Otherwise, great art would only show us beautiful things. And the beauty of any great work of art as an entity is experienced precisely because we sense its inner order, necessity, and, hence, its heightened reality. It is in this sense that scientists speak of a beautiful theory of physics or mathematics.

But are we really any closer to a means of useful criticism? We have admitted the variance in the perception of an art work from person to person and from one viewing to another. Does this not make any objective evaluation of art impossible? It certainly makes a *final* evaluation impossible. Since intuition is constantly being modified, we can never be certain whether our present evaluation of a work of art will remain constant or alter for the better or worse. But if esthetic judgment of art works must be tentative, evidence can nevertheless be provided to support it. This evidence takes the form of an analysis of the work which singles out those properties which create the illusion of heightened reality intuited by the critic. Such an analysis achieves its purpose when it provokes a corresponding intuition of a work's value by a reader who contemplates that work anew in light of the critic's insight. If the reader is unable to experience the critic's intuitions in the light of his analysis, the fault may lie either with the critic or the reader. If the reader of a piece of criticism has reason to believe that the critic's judgment is faulty, he should then try to define the properties of the art work which determine his own intuitions and point out qualities which may invalidate the critic's interpretation. The critic, if confronted by this counter-argument, may wish to modify his own evaluation, based on a new intuition of the work. In the sense that an esthetic intuition can be seriously in error no matter how intense it is, it can be compared with the intuitions of love. Love is also a recognition of value through the emotions, and it shares the same hazards as the intuition of value in art. Both can seriously misjudge the objects of their feelings, either by failing to recognize certain qualities which conflict with their feelings, or by assuming without evidence that other qualities are present in the art or loved one which are not in fact there. But the soundness of both intuition and love can be tested by observing their objects in as many situations and circumstances as possible. This does not mean that a work of art should have to function equally well in any physical setting—it has the right to be always presented to its best advantage—but it should be weighed against every other work of art and experience in life.

From the above discussion it follows that the critic's task is to articulate the kind of meaning which he intuits in the art work, to single out the qualities which make that meaning apparent, and to estimate its value. Since the meaning varies with each art work, no

fixed rules can be laid down for the critic to follow in accomplishing these ends. But I follow the practice, whenever possible, of writing about those works to which I have a strong emotional attraction and some intuition of value. Once feelings are aroused, they can be used as a geiger counter to determine what each property of the art work does to arouse them. Such testing provides new, more articulate intuitions into the fundamental meaning of the art work. Strong negative feelings can also provide a basis for a critical analysis. In the absence of any reaction, criticism can only be a pointless exercise.

The job of the critic remains fundamentally the same whether he is analyzing painting, poetry, dance, or photography. But this does not mean that a single critic is likely to be able to deal with all media equally well. In fact, few critics are able to bring the same insight even to a wide range of works done in a single medium. This is because art varies radically in the ways it makes its meaning. Although the basic task of all art critics is the same, the kind of knowledge required of a critic will vary from medium to medium, from style to style, and from work to work.

I have proposed a critical approach which would treat photographs as art. It would set no restrictions on the process by which they could be made or on the photographer's intentions, but would provide insight into their meaning and offer one kind of standard (albeit intuitively measured) for judging their worth. It would require that a photograph be contemplated without preconceived notions of what it should look like, but with the experience and sensitivity to perceive its meaning and value. And it would use any device, however analytical or metaphorical, which effectively conveyed a sense of that meaning and value.

In order to demonstrate the value of the criticism of photographs as art, I will conclude this chapter with a discussion of four photographs which pose radically different problems for the critic. The concluding chapter deals with the work of a single photographer for the purpose of showing how the criticism of a unified body of work offers cumulative insights not possible when pictures are considered independently. Yet, in keeping with my approach, each photograph is treated singly and without preconception, and, although similar stylistic devices and motifs are apparent and have been duly noted, it is their meaningfulness in their specific context within the picture with which I am most concerned.

One word of warning: the pictures which are included in this text are considered to be *reproductions*. They are produced by printing, not photography, and this inevitably alters the character of the original pictures. It is true that the alteration is often slight. But this very fact is cause for concern. We seldom forget that a reproduction of a painting is a copy, and this fact makes us hesitate to pass judgment until we see the original. But, although it is at least as difficult to gauge the fidelity with which a photograph has been reproduced, few people hesitate to judge photographs on the basis of reproductions.

I stated above that anything can be considered as a work of art; many photographers make their pictures expressly to be printed, and I see no inherent difficulty in considering such printed pictures as art works in their own right.[5] But in this study I am criticizing the original photographs as the art works, and I ask the reader to remember that the pictures he sees are only used as reproductions. The significance of this fact will depend on the picture under discussion: the Winogrand photograph is only slightly less effective in reproduction, but Uelsmann's pictures lose in tonal brilliance and in definition, and the Moholy-Nagy photogram becomes little more than a diagram of itself.

Garry Winogrand's photograph (Fig. 1) challenges many of the accepted notions of what art photographs should look like. There is little tonal subtlety, the forms are hard to see, much of the picture seems wasted and empty. And one of the most time-honored rules of painters, photographers, and other picture-makers is broken: never put the main subject in the center of the picture, especially if the rest of the picture is asymmetrical. The reason is that such an arrangement is a bit like having dessert before the meal: everything else is anticlimactic. And the long, sprawling form of the windshield, which leads our eye out of both sides of the wide picture, seems especially ill-suited to the placement of the animal and cars in its very center. But I nevertheless experienced a sense of heightened reality in this picture such that I began to suspect it was a far more significant work of art than ordinary

5. An example of a reproduction which was deliberately altered to form a new work of art is the cover of *The Persistence of Vision* (Rochester, 1967), a show catalog from the George Eastman House. By restricting the tonal range to black and white, the image has been modified so that it no longer possesses the character of the Uelsmann photograph from which it was taken.

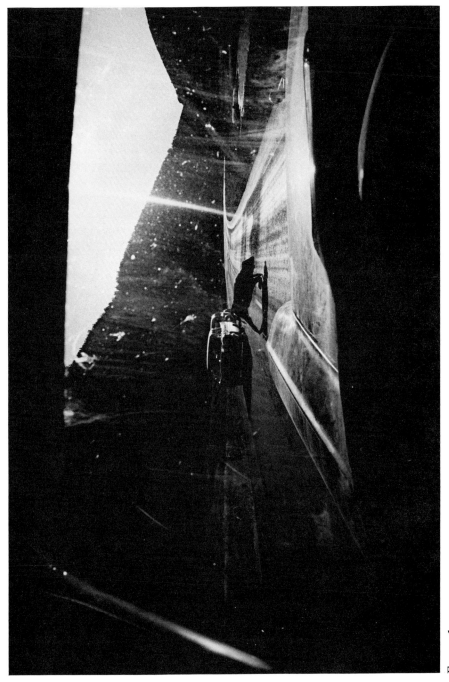

FIGURE 1

standards led me to believe. It should be interesting, then, to see
if the approach described above can offer any evidence of mean-
ing and value in this picture.

The picture is highly unusual in its direct involvement of the
viewer in a moral dilemma. Nearly all photographs permit the
viewer to contemplate them in detachment without having to be-
come involved by making a choice or commitment. Here the
viewer, as the driver of a car, is directly confronted with a di-
lemma. He sees before him an animal, probably a cow, in a help-
less position, perhaps having been hit by a car. What should he
do, try to help the animal, shoot it, notify someone? Or try to for-
get it and go on by? In a society which conceals most unpleasant
facts of life and death in slaughterhouses and slums, asylums and
prisons, many private citizens may confront a situation such as this
with feelings of embarrassment, guilt, and inadequacy. Actually,
because of the indistinctness of the animal, it is not clear that it
has been hurt: perhaps it was sitting on the road and is now get-
ting up. But the impression that the animal is wounded is hard to
eradicate and other interpretations seem like rationalizations of an
image which is unsettling to confront.[6]

If my interpretation of this picture as a dilemma involving moral
choice is accepted, it will now be possible to understand the signifi-
cance of the overall formal configuration. Presumably Winogrand
saw this event as he was driving and took his photograph with
minimal attention to composition, exposure, and focus. There is
therefore a misleading implication that the animal is the image
and that the rest of the picture is irrelevant. But the critic has no
business pondering how much control the photographer had over
his picture; his business is to explain the picture's effect, and in
my opinion, no matter what decisions were accidental, everything
in the picture heightens its meaning. The vagueness of the forms,
the bug-spattered windshield, the smallness of the animal lend an
unreal, dreamlike quality to the image at the same time that the
unpremeditated informality of the image gives it the authority of
reality. The result is an image which does what Langer describes:

6. Szarkowski points out that the war photographs of Brady and others
could not, by themselves, explain what was happening in them. "The func-
tion of these pictures was not to make the story clear, it was to make it
real" (*ibid.*, p. 9). Winogrand has exploited *both* the reality and the obscu-
rity which photography can create to produce an image which we can
neither know nor avoid and which is therefore unsettling.

it depicts an event which is intensely real, yet which separates itself from everyday reality and becomes larger than itself, more than the sum of its parts. Further, the light which streaks the windshield seems not to penetrate into the blackness of the car. This causes the viewer to perceive the dark interior of the car as being behind the windshield. The effect is like a drive-in movie screen where the event passes before our eyes or, more especially, it is like a movie which has jammed in the projector that we expect to resume again momentarily. This sense of continuity and movement is enhanced by the wide angle of the view and the curving form of the windshield which thrusts down and out of the picture plane. The animal looks as if it will topple further. The road curves away to the right like a promise of escape from the embarrassment of the animal which blocks the viewer's path. The movement tantalizes. It promises the viewer that he can pass by the event, can close his eyes to it, and it thus entices him to keep looking. The fleeting movement endures, the falling animal keeps falling, the cars inch forward but never move, and the viewer never escapes from the scene which haunts him with the persistence of a recurring nightmare. Thus we see that Winogrand's picture effectively utilizes the very quality of unsettling tension which traditional rules try to avoid. By letting the edges of the windshield run out of the sides of the picture, he encourages us to look away from this spectacle, but by centering the animal he offers us nowhere else to look.

And, although Winogrand appears disdainful of photographic craftsmanship, the fact that his picture is a photograph is vital to its meaning. Winogrand's picture is forceful because it assures viewers that it is a record of an authentic, unstaged event which really occurred, yet at the same time it has the unreality of a dream or vision. The facticity of it, combined with its strangeness, creates a powerful sense of "otherness," for the viewer is permitted a glimpse of the strange world lurking beneath the surface of everyday life, photographically documented. The above-quoted words Susanne Langer uses to describe all art might as easily have been written to fit this picture: "The form is immediately given to perception, and yet it reaches beyond itself; it is semblance, but seems to be charged with reality."[7]

Edward Weston's *Bed Pan* (1930) (Fig. 2) varies radically from

7. *Feeling and Form*, p. 52.

Winogrand's picture in that its subject is a carefully posed single form isolated in time and space and seen with an objectivity which nevertheless permits the sensitive depiction of its inherent elegance and sensuousness. But, although we instantly recognize the beauty of this picture, it raises problems for the critic which are as difficult as those posed by the first photograph. Is the real work of art the bed pan instead of the photograph? What did Weston do except reproduce it? How can a solution which is so simple have great meaning?

If we reflect on this question at any length, we must recognize that the work of art, the particular adjustment of relationship which we see here, exists in this state only in the photograph. To look at an actual bed pan would be a different experience. One might admire the lines of a bed pan as intrinsically beautiful, yet its meaning remains tied to its use. One sees it in the context of the physical world, from a variety of angles. But Weston's photograph creates the sense of otherness of which Langer speaks—a removal from time and place, a character which admits of the primary function of its subject but which transcends it. The paradox is that we recognize it as a bed pan—a mundane, even embarrassing object—but we simultaneously perceive it as an unbelievably pure form which rises and swells in space completely untainted by its use. And the simplicity with which this transformation has been achieved gives the photograph a quality of fundamental reality—a sense of something which appears before us like a vision, not something contrived or arranged.

The implied form is organic; it forcibly recalls several of Brancusi's sculptures of birds—and, indeed, this is not accidental. Weston's daybooks indicate that he had seen four of Brancusi's sculptures in the Arensberg collection shortly before he made this photograph and was deeply impressed by them. In fact, he wrote of the *Bed Pan*, "It might easily be called 'The Princess' or 'The Bird!'" naming two of the Brancusi sculptures which he had just seen.[8] Thus it is doubly astonishing that a picture which leaves the photographer so little apparent room for control could at once consciously rival the work of an artist creating in a different medium and still be immediately recognizable as a Weston. Yet such is the case. The *Bed Pan* belongs to the same family of forms as the best of Weston's peppers, shells, and nudes. Like them, it employs sen-

8. *The Daybooks of Edward Weston*, ed. Nancy Newhall, 2: 140.

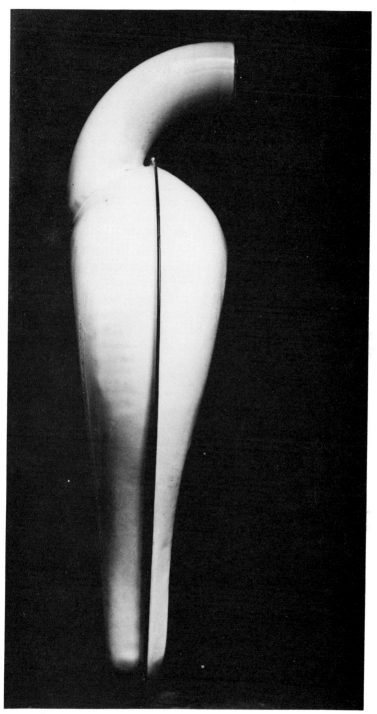

Figure 2

suousness, even sexuality, in its effects, but the forms are so puri-
fied, so raised above the mundane world, that one might better
speak of holiness than of sex. This group of photographs is as
purely classical as the Parthenon sculptures. Weston, like Phidias,
by simplifying and purifying his forms, does not generalize his vi-
sion but sharpens it and focuses it to a dazzling intensity. Both
artists reach a classical purity not by avoiding the specificness and
immediacy of physical objects or bodies but by directly confront-
ing, totally embracing, and finally transcending them. The con-
centrated feeling which the viewer senses in *Bed Pan* is not caused
by any direct expression of emotion but by the moral rightness,
the authority, the unchallengeability of the presentation. The un-
swerving certitude expressed here should be even more evident
when we consider how slight an alteration would have transformed
the photograph into a prosaic documentation of the visible world, a
sterile abstraction, or an unbearably cute animation of an inani-
mate object. The strong stamp of authority on this picture could
be compared to the sureness of the master tightrope walker who
risks danger on all sides but who performs with such command
that his audience can admire the beauty of his performance with-
out ever fearing that he could fall or even falter. The thrill of
danger exists, but it is effortlessly overcome.

The image is so flawlessly and simply presented that any formal
discussion is bound to seem petty and incapable of explaining the
picture's force. Yet some observations can profitably be made.

To stand the bed pan on its end was a fundamental decision
since it signalized Weston's unequivocal intent to let the image
function as something more than a bed pan. Such an alteration of
the normal position of an object can easily appear contrived, and
some of Weston's own pictures which depict one shell arranged in-
side of another, although they are formally lyrical, seem artificially
assembled. The blackness was likewise a crucial choice. It not only
transforms a still-life object balanced precariously on a table into a
mystical presence which rises and expands; it also lends a crisp ele-
gance to the formal character of the picture. It plays off against the
eggshell-like whiteness of the bed pan and gives force to the black
line which energizes and crystalizes the whole picture. (Hold a
pencil over this line and note how empty the picture looks without
it.)

The placement of the bed pan to the left of the picture defies tra-

ditional compositional rules about balancing weights in a picture—
yet it obviously works. The reason for its success is that the composi-
tional arrangement grows out of the meaning of the picture. If it
had been composed in terms of an object with a fixed weight, the
bed pan would have been centered and static, but Weston com-
posed in terms of the bed pan's dynamic force. The energy which
builds up in the swelling body is compressed in the neck and bent
around to be released into the right side, which expands to absorb
it. Further, the black line divides the body of the bed pan and re-
lates it to the sides of the picture so that new relationships are es-
tablished between the black and white shapes on either side of it.
The placement of the black line is intuitive, but it holds together
every part of the picture with a geometric precision. Covering up
the line makes the black area fall apart; it becomes flabby and no
longer functions as part of the image.

Finally, the small size of the print prevents the image from being
too closely identified with the actual size of a bed pan and trans-
lates it into a precious, fragile form which is more appropriate to
the meaning of the picture.

I hesitate to discuss the following photogram by Moholy-Nagy
(Fig. 3) because it is so close to the Weston in its rhythms and
tonal range, its emulation of sculptural form (the Moholy is as much
like Arp's work as Weston is like Brancusi's), and its date.
But since this resemblance has become obscured by a tendency to
regard photography in which the principle decisions occur in the
darkroom as something less than legitimate,[9] I believe it is worth a
moment to defend this picture as a photograph and as a work of
art.

It is important to bear in mind that the original photogram meas-
ures seventeen and one-half by twenty-two inches, so that the
element of scale is lost in the reproduction. At the smaller size, the
reproduction is little more than a diagram which lacks the life and
intensity of the original picture. At this reduced size, it seems to
bear out some of the objections to photograms which have been
made. Although the forms are harmonious and clearly organized,
they appear to do things which could be done better in a painting
since the mere physical substance of the paint, canvas, and use of

9. See, for example, Beaumont and Nancy Newhall, *Masters of Photog-
raphy* (New York), 1958, p. 10, and Helmut Gernsheim, *Creative Photog-
raphy* (Boston, 1962), pp. 167–68.

color would give the image a force which it lacks here. Thus, the photographer seems to have deliberately foregone the rich and varied tonal and textural range and the associative possibilities which straight photography allows and seems to have gotten little in return apart from the experimental novelty of the approach.

But the full-size photograph possesses such a presence that it silences all doubts as to the legitimacy of the process by which it was created—a presence, moreover, for which the reproduction ill prepares us. And this forcefulness is to a large degree the result of purely photographic qualities. Although a painter could create similar forms, the subtlety of the tonal gradations are uniquely photographic. They create a sense of actual forms suspended in space, which appear spontaneously, rather than forms which are constructed or built up as in a painting. Thus, although no camera is used, the effect is photographic both in the quality of its tone and the sense that actual things are recorded.

On the other hand, the Moholy-Nagy photograph differs from Weston's picture in that it is more overtly a new creation than a record of the physical world. Now, we have already seen that the Weston is likewise no mere record but a new creation. The distinction between the two pictures may thus be more in degree than in kind. But the differences reverse the equation: Weston's picture we read first as a bed pan and then in terms of its overtones and implications; Moholy's picture is perceived first as a new creation which only slowly and partially hints at the physical objects which formed it, or to put it another way, instead of the objects forming the picture, it seems as if the picture is forming the objects. The result is that the photogram is unusually unified for a photograph: one does not tend to look through it to the subject matter, but rather one perceives it directly and immediately as a total, new thing, not a copy of something else.

The most important quality which the composition possesses is a sense of self-sufficient vitality. Although we have said that the picture is a new creation, it does not appear deliberately posed by the hand of the photographer. The rings seem to develop in space in a series of planes and to create a circular flow in the picture that is picked up by the fruit-like forms, whose sinuous contours stimulate that sense of motion. Because all of the forms float in a void, this flowing movement has considerable force. The effect is that, instead of a still-life arrangement of static objects, we are presented with a

FIGURE 3

configuration which appears to be engaged in the act of self-crea-
tion. The fruit-like shapes, the womb-like enclosure of the ring, and
the coiled form which resembles an induction coil, all suggest gen-
eration or creation. This feeling of being formed is enforced by the
tilt of the rings from a stable circular shape, the unresolved quality
of the other shapes, the dematerialization of the back series of rings,
and the sense that the light emanates from within the forms.

The qualities which I have pointed out in Moholy's picture again
recall Langer's remark that a work of art "is semblance, but seems to
be charged with reality." This reality, which raises the work of art
out of the phenomenal world, is achieved here by a seamless fusion
of the subject matter, the composition, and the scale into an organ-
ically coherent reality.

W. Eugene Smith's photograph *Guardia Civil* (Fig. 4) differs
from the pictures discussed above in that it was made by a photo-
journalist and was first published as part of a piece of photo-jour-
nalism. (It appeared in 1951 in *Life* as a part of a photographic
study which documented life in a small Spanish village.) This
added function of the picture somewhat complicates the problem
of criticism, since it can be judged either as art or photo-journal-
ism. The purpose of photo-journalism is to report, document, and,
hopefully, to catch the essence of an event or situation. The indi-
vidual photographs which serve this end may be indifferently
effective as cohesive entities—it is sufficient that they express some
sense of what happened as forcefully, honestly, and meaningfully
as possible. Photo-journalism consumes itself in the process of con-
veying its information to us; it interests us in the events behind
the pictures rather than in the pictures themselves. Art tends in
the opposite direction: the longer its meanings impress themselves
on us, the less important the historical circumstances which sur-
round it seem and the more it becomes both universal and self-
contained.

Now, it is quite possible to take a photograph which functions ef-
fectively as *both* photo-journalism and art, but its presentation as
photo-journalism usually tends to obscure its importance as art since
our attention is distracted from the picture as a separate, unified en-
tity, with its force expressed in all of its parts and which has a life
independent of any other pictures which may surround it. It may
of course be possible to use photographs in larger contexts with little
disruption of their ability to function independently if the larger

context displays them as whole entities. Such a use of photographs occurs in Paul Strand and Nancy Newhall's *Time in New England,* in which the accompanying text, culled from New England documents, functions antiphonally to the pictures. Instead of trying to explain what is going on in them, it harmonizes with them as a separate, countervailing presence.

Guardia Civil suffered considerably in its original presentation as photo-journalism. *Life* spread the image across two pages, separating the soldier at the right from his companions. The picture was accompanied by a text which read, "These stern men, enforcers of national law, are Franco's rural police. They patrol countryside, are feared by people in villages, which also have local police."[10] The quality of the reproduction was adequate for the purpose of photo-journalism, but considerably compromised its effectiveness as art. Other photographs were presented on the same page on a smaller scale, so that the cumulative effect of the layout was enhanced at the expense of the individual pictures.[11]

When viewed by itself in a good print, Smith's photograph is revealed as a work of considerable force. As in the photographs discussed above, the relationships of tone, shape, and texture enforce the implications evoked by the subject so that instead of a mere record, we are presented with something which seems alive and in which every part is meaningful. Because Smith is a photo-journalist, he is committed to taking photographs which enhance but do not substantially alter the primary character of the people and events which he presents. In this respect his *Guardia Civil* differs considerably from the photographs by Winogrand, Moholy, and even Weston, who have extracted quite unanticipated implications from their subjects. But, as we have said, it is the ability of a work of art to express itself forcefully as true and vital which makes it important,

10. *Life* 30 (April 9, 1951): 126.

11. I did not discover until I had finished writing about this picture that Nancy Newhall, in a perceptive essay "The Caption, the Mutual Relation of Words/Photographs" (*Aperture* 1, no. 1 [1952]: 22–23), had used the "Spanish Village" to demonstrate points remarkably similar to mine. Mrs. Newhall's essay raises other issues, too. For example, in her remarks on the "Additive Caption," she writes that "It combines its own connotations with those in the photograph to produce a new image in the mind of the spectator—sometimes an image totally unexpected and unforseen, which exists in neither words nor photographs but only in their juxtaposition" (p. 19). In these circumstances it is clear that a new work of art is created which embraces both the picture and caption.

FIGURE 4

FIGURE 5

and this quality I believe the Smith picture shares with the first three photographs discussed.

This picture, then, is a study of three Spanish soldiers. It cannot tell us much about who they are or what brings them together here —hence the necessity of the caption in *Life*—but, if we look at the photograph as art instead of photo-journalism, it is not imperative that we know. What is expressed is a sense of how men are affected by being soldiers.

The bold massing of dark and light forms convey a sense of rude force as they jut into each other. Two of these forms—the gun barrels—are especially explicit in their implications. The thrust of light shapes into the darks has its literal counterpart in the light of the late afternoon sun, which breaks over the soldiers' faces, forcing their eyes into a squint and emphasizing the leathery toughness of their skin and hats. The soldiers do not turn away from the light but, without yielding to it, they allow it to wash over their faces. The light thus represents the forces of nature and, in a broader sense, everything else which a soldier must endure. The picture seems to describe the actual process of toughening to which soldiers are constantly subjected. Other signs of the harsh force of the light are the cracks in the rough stuccoed wall and the coarse texture of the uniforms, which the raking sunlight exaggerates.

But there is a sharp difference between the presentation of the left-hand figure and the other two soldiers. He seems younger, less tough, more handsome. He has no mustache and his gun is not visible. He does not face us directly, as do the others, but turns away and appears more pensive. His form is larger, his hat touches two edges of the picture, thereby setting up an abstract interaction of forms which is enhanced by the flat black shapes along his left side (our right), and the suppressed details give the hat a form more like that of the one Napoleon wore than the quaint hats of his friends. The resultant effect is that the left-hand soldier seems abstracted and ennobled, more removed from a specific time and place. His expression makes him appear to be wise, kind, and sad and bears a surprising resemblance to the look of pathos which was a constant feature on heads of Hellenistic warriors sculpted in the last three centuries B.C. (Fig. 5)

The other two soldiers, by their photographic facticity, provide a stark contrast to the first one. The unglamourous directness of their presentation mocks the romantic aura which surrounds him. Their

features convert his look of heroic pathos into a squint, a strictly practical response to the bright light. Their frontal heads, uneven features, strange uniforms, rudely projecting gun barrels, and the black eye of the man at the right all combine to convey the sense that these men are grimly real and that they probably carry out orders without many moral qualms.

The two sides of the picture fit together surprisingly well. The strikingly noble aspect of the front man is saved from looking posed and artificial by the factual frankness of the other two figures which convinces us of the authenticity of the scene, and the understated simplicity of their presentation is enriched by the foreground figure.

Chapter 3

THE THIRD SECTION of this study is devoted to an analysis of the photography of Jerry Uelsmann. It is undertaken to explore some of the possibilities which sustained criticism of a single photographer's work offers. It is not intended as a comprehensive study of Uelsmann's development. Although I have tried to select examples which span most of his post-student years, the pictures were chosen primarily because I sensed an artistic importance in them which I could account for, at least partially, in words. Consequently, while I hope to enlarge and confirm the reader's understanding of each picture discussed, it should be understood that certain sides of Uelsmann's work are stressed at the expense of others. It should also be noted that the progression of ideas and formal changes described is somewhat idealized. For example, although Uelsmann has tended to move progressively toward more complex and overtly manipulated photographs, his first experiments with multiple exposures predate the first picture discussed and he still makes a few photographs from single negatives. If these *caveats* are heeded, I believe that the following discussion should provide not only some insight into Uelsmann's work but a critical approach which can be adapted to the work of any photographer.

My reasons for selecting Uelsmann's work for discussion are three: it is, in my judgment, of the highest artistic quality; the rich complexity of ideas and formal interactions which pervade it make an analytical investigation of it especially profitable; and my friendship with Uelsmann has gained me his complete cooperation in this project.

Jerry Uelsmann's *Fallen Caryatids* (*ca.* 1960) (Fig. 6), although it is a straight, unmanipulated photograph, already presents many of the ideas which he develops in his later work. The subject is an

old tin balustrade which has been made to simulate a Renaissance marble balustrade. As it falls apart, peels, bends, and is perforated by what appear to be two bullet holes through the balusters, it belies all of the qualities of permanence and massive solidity to which it pretended. But paradoxically (and we will see that paradox is a frequent device of Uelsmann's photographs), although we are aware of the false vulgarity of the forms, the images which we see in the picture are elegant and lyrical. In the actual photograph, Uelsmann mellows the strong afternoon light with a warm toner. Unlike Walker Evans' *Stamped-Tin Relic* (1929) (Fig. 7), Uelsmann's presentation is sympathetic, not starkly factual. One is astonished that something which is so vulgar could be presented so handsomely. Like Evans' picture, *Fallen Caryatids* portrays the naïve vulgarity of an American culture which could manufacture Renaissance architecture in tin without esthetic qualms and could just as casually wear it out and junk it. But the sharp poignancy of Evans' photograph is tied to his scrupulously neutral style. Although he selects and composes his forms carefully, it is the quality of authenticity—the sense that these forms actually existed in a certain time and place and that their meaning is contained in their history —which makes his picture effective. Uelsmann on the other hand employs his subject matter to metaphorize the basic human experiences. The historical and geographic surroundings, although frequently very explicit in his work, are always transcended, so that the objects and figures do not seem to have ever actually existed anywhere except in these pictures. Their presence and arrangement seems urgent, necessary, and meaningful, not merely circumstantial. The sense that the balustrade is not merely debris but that it presents ideas and embodies states of being is achieved by the correspondence of the compositional axes to gravitational stresses and strains which imply a dramatic event and by its formal position which parallels the picture plane and is neatly framed by the picture edges so that it seems self-contained and complete. The background is darkened to a solid black which divorces the balusters from a specific context, makes them more abstractly formal, and makes the sense of time unreal. They thus confront the viewer directly, like saints in an altarpiece. The balusters suggest female figures—an idea confirmed by the title—and their decay metaphorizes human age and death. There is a delicious irony in the fact that the balusters are pregnant-looking for we realize that they are

FIGURE 6

FIGURE 7

empty inside. It is part of the character of Uelsmann's images that they evoke multiple associations: Duchamp's *Nude Descending a Staircase,* bowling pins, or targets in a shooting gallery all come to mind. But it is striking that these associations enhance one another. The separate ideas implied by these comparisons—serial movement downward, being knocked over, being shot down (or helplessly waiting to be shot down or knocked over)—all contribute to the richness and reality of the picture.

Uelsmann's *Secret Bulbs* (*ca.* 1961) (Fig. 8) is from the same period and has many of the same qualities as the *Caryatids.* Here again the picture is printed from a single negative, the forms are pressed against the picture plane, the darks are very black, and the timeless world of the picture seems more the product of a vision than the record of our physical world. The dark here creates an aura of secretness and protectiveness in which the naked bulbs huddle as far as possible from the white sky at the upper left which provides the only opening to the outer world. Paradoxically, the leaves, although dead, form a womb-like shelter to protect the embryonic life of the bulbs. When viewed at a distance, however, the blackness obscures the connections between the leaves, and the lighter shapes stand forth like shrouded ghosts. This is not the usual view of birth as a hopeful event, new life springing up to replace the old. There is something indecent about these bulbs. Their raw, naked forms are caught in a glaring light which picks them out of the darkness. Their small, unpleasant shapes are like a guilty secret which the viewer stumbles across in its hiding place. The placement of the bulbs in the picture's corner enhances the sense that we are accidentally glimpsing something which is not meant to be seen. But this photograph is the antithesis of a snapshot. It is arranged with such formal sureness that all sense of connection to the phenomenal world is severed. Although a quality of discovery is expressed here and thus an implication of a dramatic moment in time, this moment is prolonged into an immutable relationship and a permanent expression of reality.

The fallen leaves resemble the *Caryatids* in their rich tones (Uelsmann again uses a warm toner here), their graceful rhythms, and the dignity with which they stand erect, even in death. By contrast to the nasty rawness of birth, death here seems the nobler part.

Let us review for a moment the nature of Uelsmann's achievement in these two photographs. By staying within the traditional

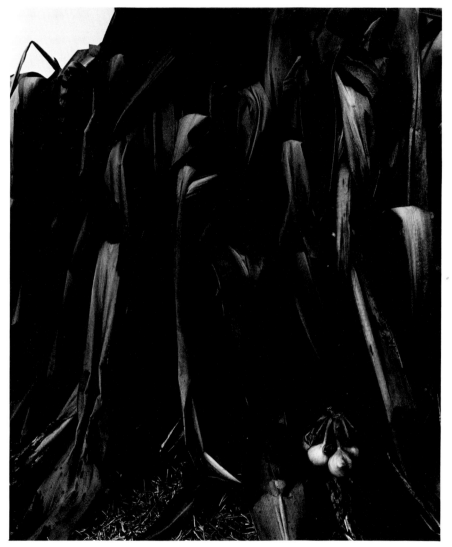

Figure 8

means of straight photography, he gives his pictures the appearance of an authentic record of actual events. He uses this appearance of documentary truth to make more forceful his presentation of abstract kinds of truth. He is able to attract the viewer through the formal elegance of the images and then gradually reveal to him the deeper implications of the pictures. The feeling that these images, so lyrically beautiful and filled with mysterious implications, were actually found in the real world gives them an amazing power and authority. But the difficulty of finding such relationships ready-made led Uelsmann to explore other means of achieving the same purpose.

Bless Our Home and Eagle (1962) (Fig. 9) represents a further step in Uelsmann's development. By making two exposures on the same negative, one with the top and one with the bottom half of the lens covered, he greatly extended the possibilities for controlling his images. But, although the bird and building were photographed separately, he still preserves here the effect of continuous space and simultaneous view. The formality which was evident in the first two pictures and the sensation that we are watching symbolic relationships are increased here. Both the eagle and the "home" are centered in the picture with the space between them disappearing into darkness. Curiously, both face sideways yet both appear frontal, the building by virtue of its symmetrical windows and the bird because of the frontal eye (strikingly similar to the frontal eyes of profile figures in Egyptian painting). Because of the formality of composition and the additive space (very much like that in the paintings of Mark Rothko and Adolph Gottlieb), the picture is to be seen not only as a momentary circumstance but as two interacting symbols whose relationship is far more than that of spatial conjunction. Even the title, *Bless Our Home and Eagle,* carries the same sense that there is no background in the picture, that both forms are to be considered equally and simultaneously as the subject. The interaction of the home and eagle functions on another level. Because the building emerges out of darkness above the eagle and because the windows are reflected in the eye, the building appears as a kind of vision conjured up in the mind of the eagle. On the other hand, the reflection in the bird's eye indicates that the bird was actually photographed inside of the building. Thus by turns both building and bird become container and contents.

The idea of life and death which we saw in Uelsmann's other pic-

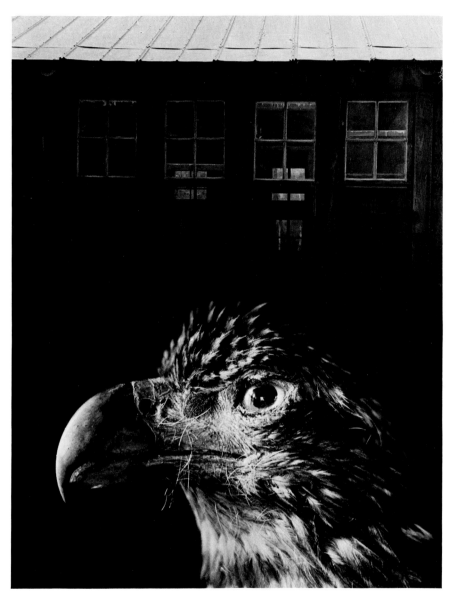

FIGURE 9

tures is apparent here, too. The bird is dead and stuffed—hence the molting feathers on its face—yet the unblinking glare of the eye conveys a fierce life. The idea of home conveyed by the title is likewise contrasted with the apparently deserted building which we are shown.

The relatively subdued social comment present in *Fallen Caryatids* has been made more explicit in *Bless Our Home and Eagle*. Indeed, judging by the title it is conceived of as the central theme of the picture. The home would seem to be a slum home, the shameful side of America; the shedding eagle seems to represent our tarnished ideals. The eye then seems to take on a reproving character which is hard to meet. The title evokes a pompous self-righteousness which ignores the shabby condition of the nation. But a number of other implications are created by the picture which confuse, rather than strengthen, these effects. First, the bird functions like a guardian figure which blocks our entry to the home. It is not immediately evident that it is dead and stuffed. Second, the building does not read like a home—not even a rural shack, because it is apparently empty and because it seems so large. A more serious criticism is that many viewers read the image as a chicken in a barnyard, and the farm-like character of the picture is so strong that even when one identifies the bird as an eagle, it is still difficult not to read it as a chicken before a chicken-house. But if the picture is somewhat ambiguous on its primary level of content, it still functions as a powerful and coherent, if somewhat puzzling, image.

Uelsmann's *Angel* (1965) (Fig. 10) represents a logical development of many of the ideas in *Bless Our Home and Eagle*. The picture can be read as a scene in continuous space and time, or as separate symbolic representations of angel, man, and flower, or as a complex relationship in which each part alters or expands the meanings of the others. As in the other pictures discussed above, Uelsmann preserves here the plausibility of the relationships so that the whole image appears to have been photographed at once. But through the more complex technique of multiple printing he is able to make more explicit and intricate the symbolic effect of his picture. Because the technique is concealed, the complexity of the image is not immediately evident, and one is at first inclined to pass the picture off as Sunday-school calendar art, very pretty but trite. It is a mark of Uelsmann's ability that he is able to make such outworn images the carriers of rich, even profound meanings. It is the

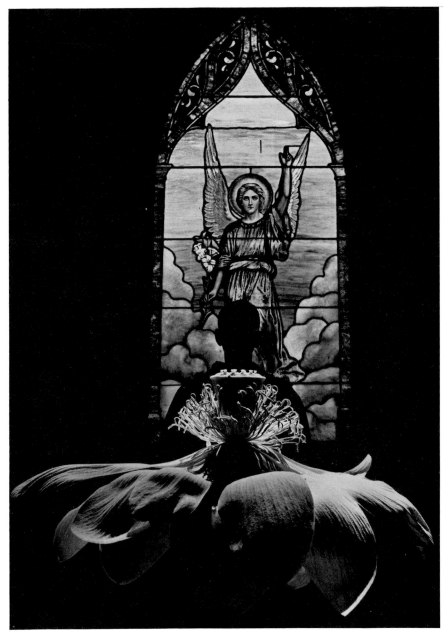

FIGURE 10

more remarkable because in this picture he disproves Henry P. Robinson, one of the best-known nineteenth-century practitioners of multiple printing in photographs, who remarked in 1892, "A painter may unblushingly present us with an angel with wings that won't work, while a photographer is laughed at, very properly, if he gives us anything nearer an angelic form than that of a spook raised by a medium."[1]

Uelsmann's angel is, of course, borrowed from a work of art in another medium, yet it is clear that the photograph greatly expands the meaning and intensifies the reality of the angel. In this sense, it is fair to say that the picture is about an angel, not about a stained-glass window. Unlike nineteenth-century photographic angels, we are not offended by this one because, although he is experienced as a dramatic presence, he is not physically real. Indeed, as a window, he is presented as light, the familiar symbol of the soul, and contrasted to the dark body beneath. The use of the ready-made angel further makes possible the presentation of a dramatic situation through a factual representation of forms; the result is at once vivid, rich in its overtones, and yet objectively documented. This solution also implies that we are witnessing not merely an unusual event—a miraculous apparition—but a fundamental relationship, something which is basic to the nature of reality.

The symmetrical, vertical arrangement of the three overlapping parts encourages this symbolic reading of the picture. The completely black sides of the picture permit the window to be read like a missile, a solid form in nebulous space which appears to thrust upward, propelled by the surging force of the lotus which forms its base. The ogee arch at the top of the window repeats the profile of the flower petals; both move our eyes upward in full, rich curves. The image of the flower is repeated in the lilies which the angel holds; the texture of its petals repeats, in a modified form, the texture of the stained glass; and, in their delicacy, their arrangement, and their feeling of floating, the petals seem like an incarnation of the wings and clouds represented in the window. The radiance symbolized by the angel's halo is recreated physically in the crown of reproductive organs displayed by the lotus. In short, the lotus is presented as a stunningly effective metaphor for the angel—and in

1. "Paradoxes of Art, Science, and Photography," *Wilson's Photographic Magazine* 29 (1892): 242–45, reprinted in *Photographers on Photography*, ed. Nathan Lyons (Englewood Cliffs, N.J.), p. 84.

broader terms for the human soul and life force—in a physical incarnation.

The flower is so arranged that its crown exactly fits within the body of the silhouetted figure. Because the figure is so dark, it tends to read as a void into which the soul, complete with nervous system, fits. Thus the picture is to be understood as a representation of man's soul in its physical, earthly form as contained within the body, and in its spiritual form as it is released in death.

But, just as a stone thrown into a pool creates rings which expand around a common center, growing ever fainter, so there are many further, more subtle implications which grow out of the central meaning of this picture. For example, the figure actually faces forward, as can be discovered by the glint of light on the sides of his eyeglasses, but his position is sufficiently ambiguous so that he may be read as facing either the angel or the lotus. Thus, the sense that the flower and angel are aspects of the same thing is heightened by the figure's mutual consideration of them.

Again, there is a complex effect of opening and closing of wing-like forms: the petals of the flower are open, but down; the clouds behind the man attach to him like raised wings; the angel's wings are still more raised; and the wing-like forms of the window-arch close over at the top—yet if we look back at the flower, we notice that its open petals form the same kind of ogee curve which closes over the top of the window. This symmetrically ascending movement of diagonal rhythms, now opening, now closing, imperceptibly conveys a sensation of the flutter of angels' wings.

I believe, however, that one quality works against the effect of this picture. The image is slightly misaligned, the window tilts to the left and the figure is placed off center in relation to the window. The result is the same as if a Gothic cathedral leaned slightly: the sense of effortlessness, of spirituality, is compromised. The sensation is no longer of movement upward, but of a pendulum-like rocking or sliding from side to side.

The untitled picture of the woman surrounded by rocks done in the winter of 1965-66 (Fig. 11) marks Uelsmann's movement toward increasingly complex printing techniques and toward a greater willingness to use effects which frankly grow out of the printing process. These effects become increasingly pronounced toward the center of the picture and they create a sense of an unfolding revelation of the core of reality. The rocks and sky at the

edges of the picture approximate symmetry in a general way; the double tree is perfectly symmetrical but still a natural form; the center axis of overlapping shapes and voids seems to be a still higher form of reality: the black and white darts and arrows which clash against each other along this axis express the hidden life force of trees, rocks, and people. The process of multiple printing has in fact uncovered a hidden reality in the tree in a very literal sense: the arrows and darts lay hidden in the image of the tree until they were found and brought to life by the symmetrical printing. The belief of African tribes, such as the Fang, that symmetry expresses life[2]—a notion which is the reverse of most Western cultural traditions—finds profound verification in this photograph. The forms here are in a constant state of tension and energy.

William Parker has described this picture as a "manifestation of the earth archetype awakened by the experience of the Archetypal Feminine" and has made a striking comparison of it with Leonardo's *Madonna of the Rocks*.[3] Such an interpretation finds verification in the presentation of the woman encased in the core of a tree and cut off at the shoulders as if she is growing out of the ground. Moreover, the viewer is given the sense that he is looking out of a cave formed by rocks which hem in his view. The woman, in size, color, and shape, relates to the rocks almost, if I may be permitted an irreverent analogy, like a football captain in a huddle with his team, viewed from below; that is, all of the forms lean over toward us and she seems to command them.

Against the earth forces are ranged the sky forces. Instead of presenting the sky as a continuous expanse, it is clustered in shapes which resemble the rocks in form and size and which push and shove against them. This struggle echoes in another mode the upward thrust of the light arrows against the downward thrust of the black arrow through the picture's axis. Much as Greek myths tried to embody in a purer form the meaning of events in the physical world, the battle along the center axis is an archetype of the interacting forms in the outer parts of the picture. The doubled image of the tree, echoing the cool, silvery tones of the sky, represents one of the powers of light which grows out of darkness and struggles to break free from it.

2. James W. Fernandez, "Principles of Opposition and Vitality in Fang Aesthetics," *The Journal of Aesthetics and Art Criticism* 25 (Fall, 1966): 53–64.

3. "Uelsmann's Unitary Reality," *Aperture* 13, no. 3 (1967): unpaginated.

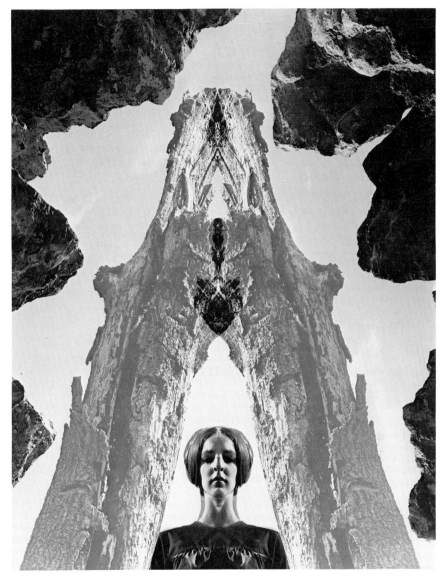

Although the woman relates to the rocks, her passive immutability contrasts with their topheavy instability. Her form is printed reversed over itself so that it is perfectly symmetrical. She is an icon to be adored in a holy shrine. The shape which surrounds her is reminiscent of the medieval Italian *mandorla,* or almond-shape, a holy space in which the resurrected Virgin or Christ appeared. Yet this inviolable space seems menaced from the picture's core by the heavy arrow-like form suspended above her head (which Uelsmann has referred to as the "sword of Damocles") as well as by the sharp rocks outside. The woman alternately appears to be the leader of the threatening rock forms and their potential victim.

The ambiguities which I have described, far from canceling each other out, are subsumed in a larger meaning which metaphorizes the nature of power and life. The woman could be compared to a lion tamer: both impose control and order on powerful, potentially dangerous forces—an order which could be utterly destroyed by the slightest failure of will.

The insight that existence is a wilfully imposed balance of dynamic forces precariously held in tension is as old as the Parthenon metopes which portray the four basic conflicts between the earth and sky gods, between the cultures of East and West, between man and woman, and between man and man's animal nature. A sense of the precariousness of this balance was experienced as recently as the assassinations of the Kennedys and Martin Luther King, which made Americans aware again of the terrible vulnerability of their leaders and spokesmen.

While the rock woman represents Uelsmann's frankest presentation of a reality outside of time and physical location, his portrait of Anne Morgan Nunez (1967) (Fig. 12) presents a kindred vision in a less immediately obvious guise. Here again he has combined symmetry with asymmetry, but with the opposite effect. In the photograph of the rock woman, the asymmetry of the exterior forms approximates the inner symmetry and seems like a less perfect echo of it; in the portrait of Anne Nunez, the placement of the central figure to one side and her informal pose momentarily conceal the symmetry of the rest of the picture. The result is that the picture disarmingly resembles a snapshot, a passing event in the real world. Only gradually does the viewer become aware that something unusual is happening in this picture.

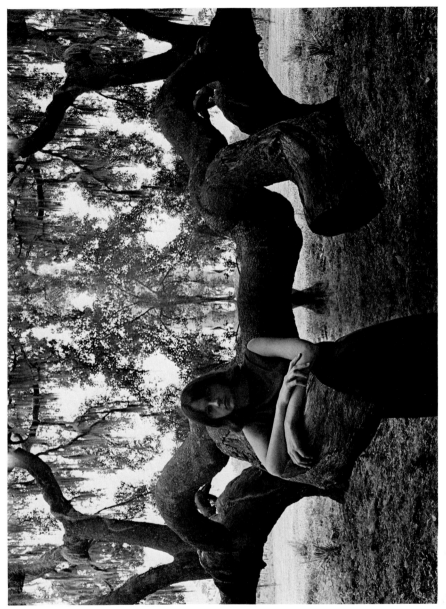

FIGURE 12

The symmetry of the picture is further concealed by the disruption of the inner contour of the left tree limb, which consequently seems different in shape and amount of spatial projection from its twin on the right side. The viewer is impelled to shift his eyes back and forth, to examine the details carefully to assure himself of the reason for this paradox. The horizontal movement from one side to the other is encouraged and articulated by the flowing lines of the tree. The convergence of branches at points at the outer extremities of the picture creates identical dramatic events of equal intensity which pull the viewer's eyes to the edges of the picture. The resultant effect is one of great breadth and expansiveness.

As in the rock woman, the figure in this picture has an ambivalent relationship with the natural forms. The embrace of the tree may be read as threatening or protective: threatening because the symmetrical tree has an octopus-like quality of expansiveness, of a natural force which seems to slowly spread out over the whole picture. On the other hand, the pose of the woman establishes her familiarity with the tree and her control over its movements. Like the circus girl who trains the elephant to pick her up with his trunk without harming her, or the lion tamer who puts his head in the lion's mouth, a feeling of human control over great natural forces is suggested here.

In the feeling that the woman holds a great force under control, this picture reiterates a theme enunciated by the rock woman. Other themes are also developed here which were noted in our discussion of the earlier work. The struggle between darkness and light, more subdued here, can be observed where the sky is crowded into stagnant pools of light by the foliage and in the erosion of the dark limbs by the light which eats into the edges. And the snake-like windings of the tree are a manifestation of the chthonian powers of the woman, much as the rocks were in the previous picture.

I feel that the picture is remarkably successful because it combines all of the immediacy and historicity of a snapshot with all of the symbolic richness of an archetype, and it does so with a kind of effortless command which is reminiscent of the Renaissance ideal of the *gran maniera*. I do feel, however, that, whereas the shapes which were created along the center axis of the photograph of the rock woman formed a vital part of the picture's meaning, similar shapes which emerge along the axis of the present picture,

especially the twinned tree trunk, work against the subtlety of the symmetry and the actuality of the situation.

The untitled photograph of positive and negative male figures walking on twin stone fences, printed in 1967 (Fig. 13), represents Uelsmann's former teacher, Ralph Hattersley. The symmetry employed in the last two pictures is now varied by the use of positive and negative images with a resultant modification of meaning. The struggle between body and spirit and between light and darkness, so frequently noted in Uelsmann's other work, here finds a direct expression in the positive–negative opposition. The symmetry is complete, except for a third exposure lightly printed through a photograph made from the whole negative. But the effect, as in his earlier pictures, is a mixture of symmetry and asymmetry which is created largely through the simple interaction of the positive and negative of the same image. The images of the men on the matching walls are roughly symmetrical in their effect, but only the positive tree trunk is visible and it appears to be the source of both the positive and negative branches. The elaborate intertwining of its limbs so dazzles the viewer that the passage from light to darkness is deftly concealed. Opposites are brought together in a single world, wedded by the unifying tree.

The picture is more clearly removed from the everyday world than any work which we have thus far considered by Uelsmann. Nevertheless, more than the other works, it tends to draw the viewer into its enveloping, volatile environment rather than to present him with a series of immiscible forms to be contemplated in detachment and at leisure. Much of this effect is caused by placing the figures at the outer edge of the picture, so that it is difficult to take them both in at once. The restless, shifting glances which are required to view this picture witness an elusive world which dissolves and breaks apart as soon as it is assembled. Yet through this chaos there is visible the clarity which marks all of Uelsmann's work. The basic elements, man, wall, and tree, despite their complex interrelationship, stand forth clearly as cohesive symbolic entities. The complete effect is a heightening of the tension between forms as entities and as interpenetrating parts of each other with overlapping meanings.

For example, the wall at the left opposes its solid massiveness and its thrust back into space to the tree's open tangling movement in all directions. But at the right the wall opens up in molten

pockets of light, its thrust into space is cut off, and it appears to
dissipate upward into the fiery branches. The negative branches
printed over the right-hand figure ensnare the man in the tree and
permeate his body. Their pervasive encroachment enhances the
ambivalent impressions that either the man is hanging like a fruit
from the tree and is under its power or the tree is a projection of
the man's nervous system. In either case the tree is the active force
in the picture, a kind of spirit which bursts out of the containing
body of the wall.

Strawberry Day of 1967 (Fig. 14) moves back to the additive
space seen in *Bless Our Home and Eagle* of 1962. The transition
between images is masked by flat black so that each one is simply
and forcefully presented. But there is no attempt here, as there
was in the earlier pictures, to integrate the parts into a cohesive
space. The landscape, the strawberry, and the girl are presented
as separate entities. The relationship suggested is much like that in
an altarpiece with the Madonna or Christ in the center and saints
standing on the sides. Nevertheless, the forms do not stay in this
planar arrangement but are forced back and forward by their di-
verse scales. As the landscape drops back, it hollows out a continu-
ous black void in which the strawberry floats forward at us like a
vision. As it floats out in front of the girl, the strawberry acquires
the connotation of something which she is dreaming of. The girl is
tied to the landscape by the sun which appears to illuminate her.

Many of the themes developed by Uelsmann in his other work
recur here, such as the interaction between light and darkness and
the emphasis on woman's relationship with the earth and fruition.
But a theme which is developed here in greater depth than in the
pictures discussed above is the quality of introspection and self-
discovery. Despite the formality of the presentation, the girl's mood
and action lends a poignant delicacy to the picture which was not
present in the other photographs discussed above. Those pictures
tended to be cool in the sense that they seemed to represent objec-
tive relationships of forms which, if they moved the viewer, did so
because of their intense reality and presence. In *Strawberry Day*,
the girl's thoughts and feelings become the subject matter of the
picture in a more overtly romantic manner. The girl holds her head
in her hands in a way which suggests deep thought. The sense of
being far away in thought is metaphorically expressed by the land-
scape, which represents not only physical distance but the ancient-

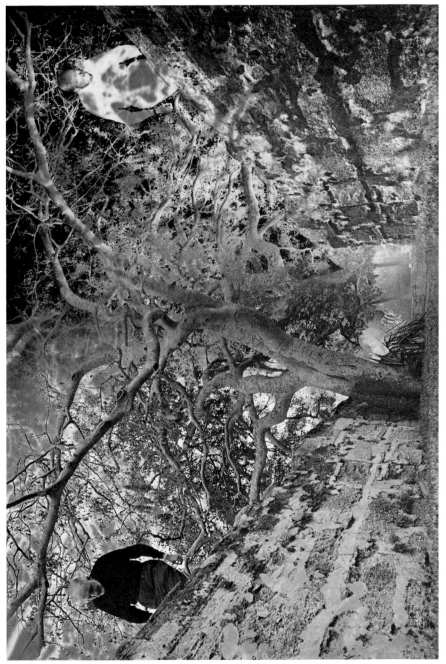

FIGURE 13

ness of a forest where the sun seems not yet to have shone and the icy coolness of a light which fractures into thousands of brittle fragments before it can penetrate to us.

The girl's hands, cut off from her body by the heavy cloth, which also obscures any temporal reference, seem to function unheeded by the head, and this effect increases the picture's implications. The fingers touch the face as if gently exploring it and thus emphasize the delicate softness of the skin. The sensuousness of the girl's head and its shape—divorced, as it is, from her body—associate it with the strawberry which has the same kind of fragile beauty. Uelsmann has remarked that he likes strawberries because they are the only fruit which carry their seeds on the outside,[4] and this observation is full of significance for an understanding of this picture because the seeds express a vulnerability which makes the directness and openness with which the strawberry presents itself to us intensely poignant.

The photograph can thus be understood in terms of a play between immediacy and remoteness, between inside and outside, between darkness and light—a balancing of opposites in which the contradictions do not neutralize but rather intensify each other.

William Parker has approached many of Uelsmann's photographs of women in terms of their intuition of an archetypal earth mother. Such an interpretation of *Strawberry Day* is, I believe, legitimate, even obvious. Yet I am not persuaded that it is capable of illuminating all or perhaps even the major implications of this picture. In the event that this point has not been convincingly made by my above analysis, I wish to suggest another kind of meaning which I believe the picture contains or, more properly, a different application of the meanings analyzed above. It seems to me that the picture bears on the psychological state of the artist. I do not mean that Uelsmann reveals his own feelings here (that may or may not be true), but, rather, I mean that he has metaphorically conveyed the quality of *all* artists' feelings. Expressed in this photograph is the sense of the artist's introversion and self-exploration, his attempt to capture and present something tangible and substantial and authentic out of his remote, evanescent feelings about himself

4. Uelsmann was hesitant to be quoted on this point since he has never verified the truth of his remark. But that is of no importance. What *is* important is that the statement provides us with a vivid insight into the picture.

FIGURE 14

and the world which surrounds him. This interpretation is ancillary to the main meaning of the picture, but I believe that its legitimacy will be confirmed by a contemplation of the photograph itself.

Uelsmann's untitled photograph of unfolding rocks above an image of the circulatory system (1968) (Fig. 15) is one of his most complex and forceful works. In it he has employed positive and negative images, a photograph of an engraving, a black square created photographically, and a format which disrupts the traditional rectangular borders of a photograph. Through this complex assemblage of forms he has created a picture of great richness and intricacy in which areas of varying tonal ranges interweave and enhance each other. Yet the photograph has been made with such authority that, despite the obvious difficulty of the technique, the forms function as a coherent image which seems to have miraculously and spontaneously appeared.

Uelsmann has used the shape of this picture as a structuring device in a manner which closely parallels the paintings of Josef Albers and Frank Stella. The symmetrical rock form which touches the top and bottom of the outer frame is the negative image of the smaller rock framed by the inner square. This sets up a throbbing movement in and out, from large to small, from negative to positive—an expansion and contraction like a heartbeat. This expanding movement is enhanced, as in Albers' pictures, by lining up the thrusting corners of the inner square with the outer corners. Since the inner square floats without support, it is charged with energy to expand, contract, move in or out of the picture. The in-and-out movement is strengthened by the alignment of an inner contour of the negative image with the outer contours of the inner rock and the intrusion of the larger image within the inner square where it acquires a silvery tone. Thus, instead of perceiving two discrete images, we see a series of interwoven forms with concentrations of energy along horizontal, vertical, and diagonal axes, all of which pass through the center of the outer square.

The whole image appears like a holy apparition in the sky. This method of presentation metaphorizes the idea that an art experience, like a religious experience, is a direct kind of revelation in which the meaning unfolds before us, mysterious but intensely vivid.

The small figure at the bottom, taken from Vesalius, is a curious

choice of an image and difficult to explain in terms of the overall meaning of the picture. The outer forms of the rocks fold around him in a protective embrace. The man stands in an open stance which reveals his entire being—already exposed to our eyes by the removal of his skin, muscle, and bones. In a number of significant ways this photograph bears a striking resemblance to Uelsmann's angel picture. In both cases we are presented with a holy apparition charged with great energy, which appears above a man whose individuality is concealed (or stripped off) but whose insides are completely exposed and who can be read as facing in or out. But the photograph of the rock apparition cannot be understood in terms of life and death as can the earlier picture. The relationship seems to be one in which the rocks emanate out of the man like a projection of his inner being which he is trying to stand back from and read. The inner frame gains a new meaning in this interpretation; it looks like a movie screen, or an X-ray photograph through which he see the inner being of the outer image. The sense of examining one's insides is of course repeated by the exposure of the man's circulatory system. And the double aspect of the figure, facing in or out, means that he is not only examining himself, but is exposing himself to us. As in *Strawberry Day*, this sense of self-examination is meaningful as a symbol of the artist's process of self-discovery.

But the presentation of the rocks hovering in mid-air suggests that they represent not only the artist's inner being but also a planet, a world. Uelsmann may not have been consciously influenced by Leonardo's drawing which illustrates the statement by Vitruvius that a man of perfect proportions would fit within a circle and a square (Fig. 16), yet the resemblance extends beyond the formal similarity. Both works express the attitude that the same mysterious laws which control and order the universe are the keys to understanding the nature of man because man is a model of the universe.[5] The greatest difference is that in Leonardo's drawing the

5. For an exciting discussion of the use of geometry to symbolically relate God, man, and the universe, see Rudolf Wittkower, *Architectural Principles in the Age of Humanism* (London, 1952). It is interesting that Uelsmann owns a student painting which is clearly based on Leonardo's drawing—a point which I suddenly realized as I was in the process of asking him whether he was familiar with the drawing (he was, but was not conscious of it as an influence). He also showed me a version of the photograph in which the figure was placed inside the square as well as below it.

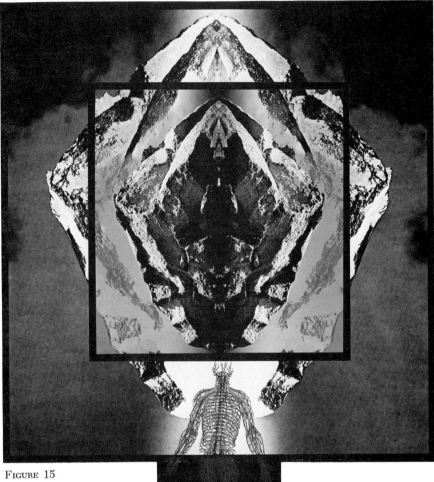

Figure 15

Figure 16

man is only an object to be studied whereas in Uelsmann's picture the man is both the object and the viewer. Although the projecting square at the bottom of the photograph establishes his spiritual unity with the black square and the frame of the picture, it enables the man to stand back from the rock image and contemplate it. It enables him to literally stand outside of the picture.

But more than the man's inner being and an image of the world, the picture represents the Dome of Heaven and the very face of God. The similarity between this picture and the ancient representations of the Dome of Heaven is remarkable, as is its resemblance to the visions of Ezekiel and St. John.[6] But Uelsmann, through the photographic actuality, rich complexity, and the dynamic energy of his picture has far transcended the frequently diagrammatic character of these earlier representations and descriptions and has given his image the force of a living presence.

Uelsmann's photograph of covered cars from a carnival ride (*Tiltawhirl*, 1968) (Fig. 17) possesses many of the traits which we have observed in his earlier work, such as the lyrical monumentality of the forms and the play between symmetry and asymmetry. On the other hand, the picture departs from most of his work in an important way. Where the other photographs present worlds which transcend time and place—even when they are straight shots—this picture is presented in the broad daylight of the phenomenal world. The bright, clear forms of the painted railings and braces give the picture an up-to-date look which is quite at variance with the natural forms and old buildings with which Uelsmann has usually furnished his pictures. At the same time, the four images printed in this picture are so subtly combined that the viewer receives a strong initial impression that he is viewing a straight, unmanipulated photograph. To be sure, a close examination reveals the seams where the separate pieces of the picture are joined; the photograph is plausible as a straight photograph primarily because its powerful implications are so understated that we sense them long before we can find any visible reason for them and because the multiple printing departs so slightly from the

6. See Karl Lehmann, "The Dome of Heaven," *The Art Bulletin* 27 (1945): 1–27. Especially striking, in its revelation of forms within forms, is "Man at the Center of the Universe," St. Hildegard of Bingen, *Liber divonorum operum*, 13th century, reproduced in *Encyclopedia of World Art*, 7, plate 375.

FIGURE 17

effect of a naturally occurring image that we are not at first warned to look for evidence of it. The symmetry, although it heightens the sense of presence which the picture has, is entirely appropriate to the regular forms of the cars and passes unnoticed in the generalized form of the cloth folds, and the somewhat sprawling space resembles that in a photograph taken with a wide-angle lens. The result is that the picture, without losing its force as an objectified relationship, acquires the immediacy of an actual event.

In all of the pictures discussed above, Uelsmann found or created a setting in which the figures and things depicted seemed at home. Even in a picture as blatantly assembled as the photograph of the rock-vision, there was a milieu established to which everything seemed to belong. By contrast, the forms of the covered rides and the stains on the pavement in the amusement park picture seem like rude intrusions which upset and disturb an everyday scene. The inability of the objective quality of photography and the sharp, cold light of day to dispel the sense that we are witness to an ominous apparition—in fact their intensification of the reality of this apparition—is an amazing achievement. For the most part it has been accomplished by implication rather than being spelled out, but even the blatant presentation of the pod which appears in the center canvas shape does not seem to disrupt the reality or coherence of the scene.

The theme of the picture is birth and death, a theme which recalls the first two of Uelsmann's photographs which he looked at. The negative form of the pod, seen either as an emblem on the outer surface of the canvas or perceived within through transparent material, states the theme of birth, which is also carried out by the great swelling forms of the other canvas covers which hold the rides. In a sense, every day when the covers are removed the rides are reborn and at night they form shrouds to conceal the dead rides. The stains in the pavement which are so insistantly thrust before us and which disappear under the two shrouded forms—or perhaps trickle out from under them—also have implications of death, especially violent death. There is a sense that something terrible has happened under these covers. The contrast between the normal state of a carnival ride—full of life, movement, and gaity—and the waiting, expectant mood conveyed here is entirely appropriate to the contrast betwen life and death.

From the preceding examination of Uelsmann's pictures, I hope the reader may be persuaded of the extreme usefulness of subjecting photographs to the same kind of sustained analysis which scholars and critics have usually reserved for the other art media. The greatest photographs all possess a rich complexity which eludes simple explanation and which is capable of rivaling the best paintings and sculpture as important art. It is time that photographic historians pass beyond the chronicling of biographical and technological events and collating photographers' statements of intent; these are valuable and welcome contributions to scholarship, but they cannot substitute for a discusion of the photographs themselves as unique works of art. It is undeniably true that Uelsmann's photographs are especially susceptible to such discussion, but, as the analysis of the other four photographs in part two of this book should demonstrate, any photograph which has value as a work of art—that is, a thing which is important in and of itself —can be profitably analyzed.

Bibliography

THE BIBLIOGRAPHY which follows is designed to provide further reading in each critical attitude which has been discussed. The reader is cautioned to note that these groupings are not rigidly bounded: the esthetic categories occasionally include widely divergent viewpoints under one heading, and many of the critical writings encompass several esthetic viewpoints. My main concern has been to give the reader as wide a selection of different approaches as possible. This has led to the inclusion of writings which range from perceptive to downright foolish.

1. Pictorialism
 a. Esthetics
 Anderson, P. L. *Pictorial Photography, Its Principles and Practice.* Philadelphia, 1917.
 "Monsieur Demachy and English Photographic Art." Remarks by A. M., Robert Demachy, G. B. Shaw, F. H. Evans, F. M. Sutcliffe. *Camera Work* 18 (April, 1907): 41–49.
 Robinson, Henry Peach. *Pictorial Effect in Photography.* London, 1896.
 Tilney, F. C. "What Pictorialism Is." *The Photo-Miniature* 16 (January, 1924): 565.
 b. Criticism
 Caffin, Charles H. *Photography as a Fine Art.* New York, 1901.
 Hartmann, Sadakichi. "Gertrude Käsebier." *The Photographic Times* 32 (May, 1900): 195–99.
 ———. "Rudolph Eickemeyer, Jr." *The Photographic Times* 32 (April, 1900): 161–66.
 Johnston, J. Dudley. "The Art of Alexander Keighley, Hon FRPS." *The American Annual of Photography 1949* 63: 7–22.

2. Purism
 a. Esthetics
 Craven, Thomas. "Art and the Camera." *Nation* 118 (April 16, 1924): 456–57.
 Eastlake, Lady Elizabeth. "Photography." *London Quarterly Review* (American edition) 101 (1857): 241–55.
 Gernsheim, Helmut. *New Photo Vision.* London, 1942.
 Pennell, Joseph. "Is Photography among the Fine Arts?" *Contemporary Review* 72 (1897): 824–36.
 Weston, Edward. "Techniques of Photographic Art." *Encyclopaedia Britannica* 17 (1957): 801–2.
 b. Criticism
 Agee, James. "A Way of Seeing." Introductory essay in: Helen Levitt, *A Way of Seeing.* New York, 1965.
 Greenberg, Clement. "The Camera's Glass Eye." *Nation* 162 (March 9, 1946): 294–96.
 Tillim, Sidney. "Walker Evans: Photography as Representation." *Art Forum* 7 (March, 1967): 14–18.
3. Intentionalism
 a. Esthetics
 "Ask These 20 Questions Whenever You Study a Picture." *Popular Photography* 42 (March, 1958): 60–61.
 Chappell, Walter, and Minor White. "Some Methods for Experiencing Photographs." *Aperture* 5, no. 4 (1957): 156–71.
 Hattersley, Ralph. "Notions on the Criticism of Visual Photography." *Aperture* 10, no. 3 (1963): 91–114.
 Kraszna-Krausz, A. "Criticism of Photographs." *The Focal Encyclopedia of Photography.* New York, 1960, pp. 281–82.
 b. Criticism
 "Editors Read Eleven Pictures." *Popular Photography* 42 (March, 1958): 70–82.
 Gutman, Judith Mara. *Lewis W. Hine and the American Social Conscience.* New York, 1967.
 Perrin, Stephen G. "Editorial." *The Boston Review of Photography* 3 (November, 1967): 9–10.
4. Reading
 a. Methodology
 White Minor. "What Is Meant by 'Reading' Photographs." *Aperture* 5, no. 2 (1957): 48–50.
 b. Readings
 Durrell, James, Jr. "Application of a Formal Method for Reading 'Pictorial' Photographs." *Aperture* 6, no. 2 (1958): 84–86.
 "The Experience of Photographs, 5 Photographs by Aaron Siskind, 5 Readings by: Kurt Safranski, Henry Holmes Smith, Myron Martin, Walter Chappell, Sam Tung Wu." *Aperture* 5, no. 3 (1957): 112–28.
 "An Experiment in 'Reading' Photographs: A Consolidation of Readings by Students at the Rochester Institute of Technology." *Aperture* 5, no. 2 (1957): 51–75.
 Smith, Henry Holmes. "Image, Obscurity and Interpretation." *Aperture* 5, no. 4 (1957): 136–47.
5. Archetypal Analysis
 Parker, William E. "Uelsmann's Unitary Reality." *Aperture* 13, no. 3 (1967): unpaginated.

UNIVERSITY OF FLORIDA MONOGRAPHS

Humanities